Georgia O'Keeffe

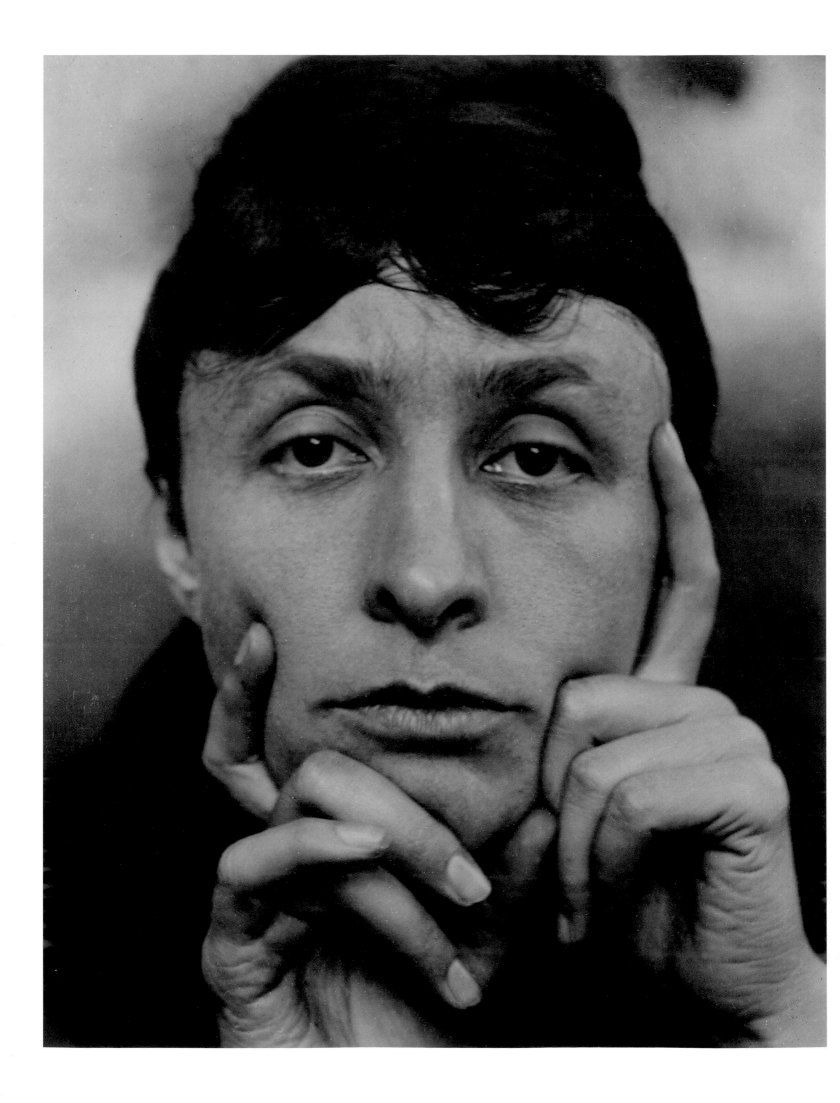

Britta Benke

GEORGIA O'KEEFFE

1887–1986

Flowers in the Desert

Benedikt Taschen

FRONT COVER:
Jack-in-the-Pulpit III, 1930
Oil on canvas, 101.6 x 76.2 cm
Washington (DC), Alfred Stieglitz Collection,
Bequest of Georgia O'Keeffe
© 1994 National Gallery of Art
(cf. p. 43)

ILLUSTRATION PAGE 2:
Alfred Stieglitz:
Georgia O'Keeffe: A Portrait – Head, 1918
Enlarged gelatin silver print
Washington (DC), Alfred Stieglitz Collection
© 1994 National Gallery of Art

BACK COVER:
Alfred Stieglitz:
Georgia O'Keeffe, 1918
Silver chloride print
Chicago (IL), Photograph courtesy of the Art
Institute of Chicago, Alfred Stieglitz Collection, 1949.742
(cf. p. 7)

**This book was printed on 100% chlorine-free bleached
paper in accordance with the TCF standard.**

© 1995 Benedikt Taschen Verlag GmbH
Hohenzollernring 53, D-50672 Köln
© 1994 Paintings by Georgia O'Keeffe otherwise uncredited in
this book are published with the permission of the
Georgia O'Keeffe Foundation insofar as such permission
is required. Rights owned by the Georgia O'Keeffe
Foundation are reserved by the Foundation / VG Bild-Kunst, Bonn
Text and design: Britta Benke, Bonn
Captions: Rainer Metzger, Munich
Cover design: Angelika Muthesius, Cologne
English translation: Karen Williams, Wall

Printed in Germany
ISBN 3-8228-8886-9
GB

Contents

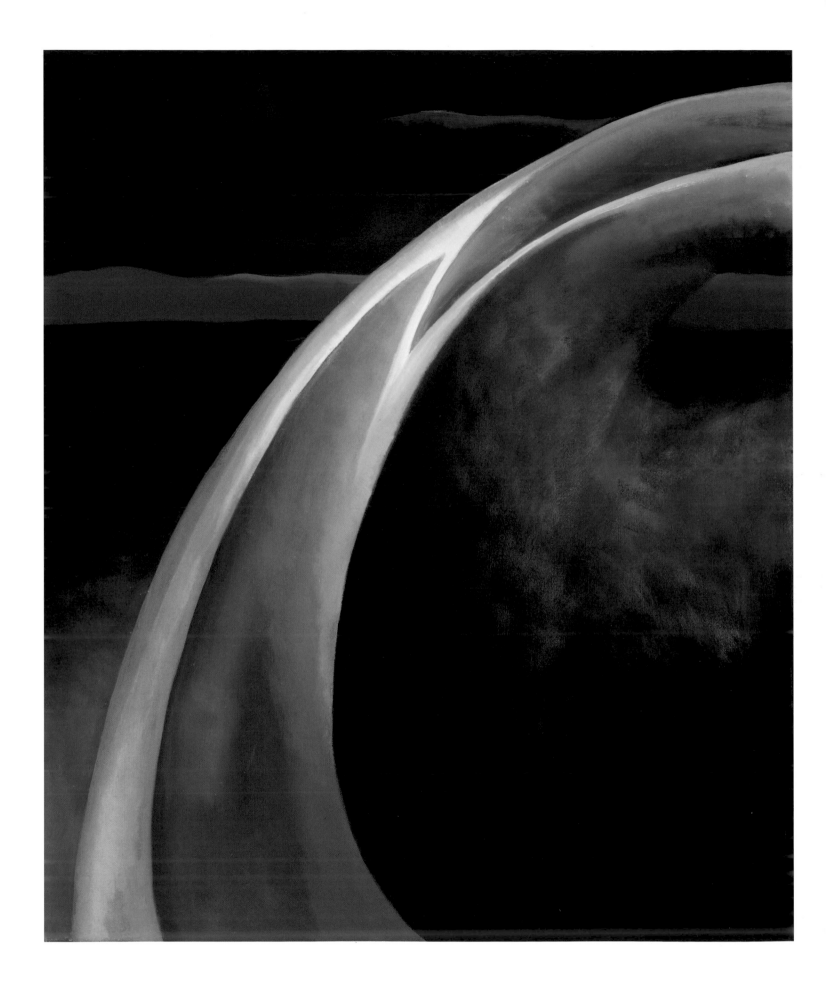

Inspiration and intuition

The great popularity of Georgia O'Keeffe (1887–1986), and her outstanding position in American art, are to be attributed not only to her painting, but also to her remarkable personality – as a woman who established for herself an independent and legendary life in the wilds of New Mexico. Her career as an artist spanned over half a century, a period ranging from the early days of American modernism to the abstract tendencies of the fifties and sixties. The fame of her pictures, which resonate with expressive force of colour and encoded sensuality, has long since travelled across the Atlantic. Her subjects – above all her magnified flowers and her New Mexico landscapes – reflect her intimate bond with nature.

Georgia O'Keeffe grew up in the American Midwest, on the rolling plains of Sun Prairie, Wisconsin. She was born on 15 November 1887 as the second of seven children to Ida Totto O'Keeffe and Francis Calyxtus O'Keeffe. She spent the first twelve years of her life on her parents' farm. The rhythms of the agricultural year – the golden fields of corn – would leave a powerful and enduring impression upon her, one which would later reverberate throughout her work. To offset the isolation of farm life, especially during the long winter months, the O'Keeffe children found welcome distractions in music and adventure stories from the Wild West. Georgia and her younger sisters also took lessons in painting and drawing, for which they were driven to the nearby town of Sun Prairie. Indeed, by the age of twelve Georgia had already made up her mind to become an artist.

When she was fifteen, her family left Wisconsin and moved south to Williamsburg, Virginia. She was sent to board at the private Chatham Episcopal Institute, where she often escaped from the rigid scholastic routine on long walks in the surrounding hills and forests. Georgia's talent was spotted by her art teacher, who encouraged her in her decision to study painting. At seventeen she enrolled at the school of the Art Institute of Chicago. There she joined the anatomical drawing class run by John Vanderpoel. Vanderpoel emphasized the function of line as a physically structuring contour, a lesson Georgia found particularly valuable. In 1906, however, O'Keeffe's studies were abruptly interrupted by typhoid, a potentially fatal illness which confined her to the family home in Williamsburg for several months.

In autumn 1907 she set off for New York to continue her studies at the Art Students League, the most famous art school of the day. She joined the class run by William Merrit Chase, who focused his pupils' attention on living textures and the materiality of colour. He urged his students to paint a picture a day, an exercise designed to encourage them to attach more importance to the working process than to the final result. As at the Art Institute of Chicago, however, teaching at the League was largely geared towards the his-

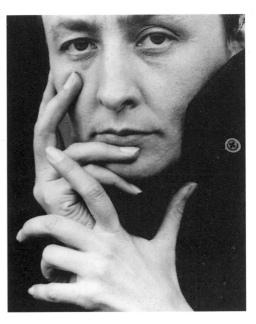

Alfred Stieglitz:
Georgia O'Keeffe, 1918
Silver chloride print
Chicago (IL), Photograph courtesy of the Art Institute of Chicago, Alfred Stieglitz Collection, 1949.742

ILLUSTRATION PAGE 6:
Orange and Red Streak, 1919
Oil on canvas, 68.6 x 58.4 cm
Philadelphia (PA), Philadelphia Museum of Art: Alfred Stieglitz Collection, Bequest of Georgia O'Keeffe

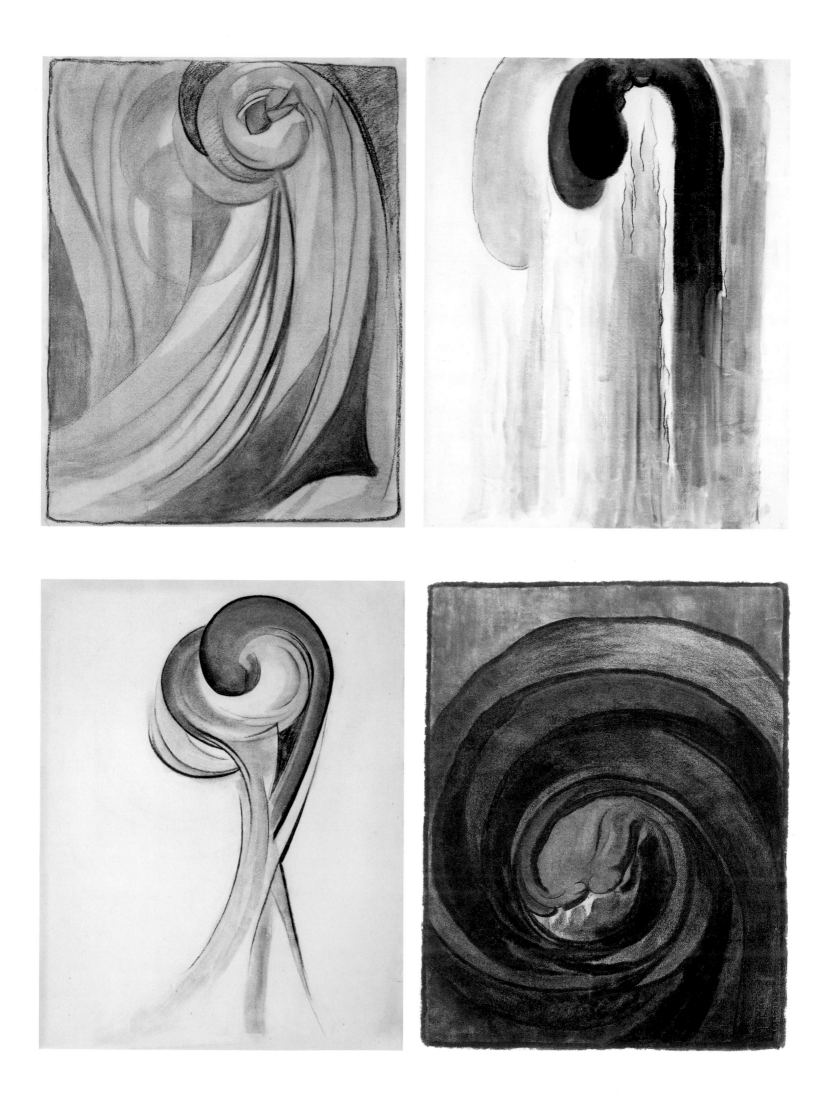

Light Coming on the Plains III, 1917
Watercolour, 30.2 x 22.5 cm
Fort Worth (TX), Amon Carter Museum

The light on the horizon: in this watercolour,
Georgia O'Keeffe is concerned with a literally
everyday experience, namely sunrise. At the
same time, she formulates a typically romantic
metaphor for the power of all-encompassing
nature.

toricism of European tradition and towards copying in the style of the Old
Masters. The only counterweight to the conservative climate prevailing
within the New York art world was provided by "291", a small gallery run
by the photographer Alfred Stieglitz (1864–1946) and named after the num-
ber of the building on Fifth Avenue in which it was housed.
Long before the legendary Armory Show of 1913, which brought the art of
the European avant-garde to the attention of a broader American public,
Stieglitz had been honouring revolutionary modern works such as those by
Henri Matisse and Paul Cézanne with exhibitions in his gallery. O'Keeffe
visited these exhibitions with fellow students from the League; it was in
"291", in 1908, that she saw drawings by Auguste Rodin, and later works by
Matisse, Braque, Picasso and the Americans John Marin and Marsden Hartley.
Although Chase awarded her a prize for the best still life of her class in
1908, O'Keeffe was disheartened by the one-dimensional academic approach
which simply advocated the imitation of other styles. This, coupled with the
fact that her family was finding itself in increasingly straightened circum-

stances, led her to break off her studies and embark upon a career as a commercial artist in Chicago, designing company logos and advertisements.

It was not until 1912, when she attended a summer course at the University of Virginia, that painting once more began to play a dominant role in her life. She joined a class run by Alon Bement, who propounded the theories of Arthur W. Dow, head of the Faculty of Fine Arts at Columbia University Teachers College in New York. Inspired by the decorative principles of Oriental art and Art Nouveau, Dow had arrived at an abstractive, two-dimensional style which was far removed from the pure imitation of nature. Following Eastern ideals, Dow argued for the adoption of simplified, clear forms in order to bring out the essence of things. O'Keeffe's interest was particularly aroused by Dow's emphasis upon the careful and balanced arrangement of all the elements of the composition – colour, form, line, volumes and space – in order to arrive at a harmonious overall design.

O'Keeffe subsequently returned to the University of Virginia for the summer of 1913 as Bement's teaching assistant. In autumn 1914 she also returned to New York, this time to study under Dow himself for two semesters. At Bement's recommendation, she read Wassily Kandinsky's *Concerning the Spiritual in Art*, which had just been translated into English. Kandinsky's fundamental thesis, namely that colour and form should no longer be indebted to outward appearances in nature, but rather to the feelings and "inner world" of the artist, would have an enduring influence upon O'Keeffe's attitude to painting. It was also during this period that she was introduced to the organic pastels of her contemporary Arthur Dove (1880–1946), who was similarly exploring the possibilities of abstract forms of expression in painting. In Dove's work O'Keeffe found an equivalent of her own artistic vision: the symbolic translation of uniquely personal experiences into abstract form.

Inspired by these new ideas, in autumn 1915 Georgia O'Keeffe started tracing out her own path as an artist. Now based in Columbia, South Carolina, where she had accepted a teaching post at Columbia College, she executed a

Special No.15, 1916
Charcoal on paper, 48.3 x 62.2cm
Abiquiu (NM), The Georgia O'Keeffe Foundation

Charcoal drawings sketched on site, in this case at Palo Duro Canyon, capture impressions which Georgia O'Keeffe subsequently transfers into emphatic paintings which go far beyond their original starting-point.

series of remarkable charcoal drawings, whose genesis she later described as follows: "I said to myself, 'I have things in my head that are not like what anyone has taught me – shapes and ideas so near to me – so natural to my way of being and thinking that it hasn't occurred to me to put them down.' I decided to start anew – to strip away what I had been taught – to accept as true my own thinking. [...] I was alone and singularly free, working into my own, unknown – no one to satisfy but myself." O'Keeffe sent these new drawings to an old friend from Teachers College who was still based in New York, who in turn showed them to Alfred Stieglitz. Profoundly impressed, Stieglitz described them as "the purest, finest sincerest things that have entered '291' in a long while".

In O'Keeffe's charcoal drawings – which she later named "Specials", in order to stress their particular significance for her and her art – the surface is filled by organic and geometric forms. Some of these forms are reminiscent of plants and buds, as for example in *Special No. 4* of 1915 (p. 8, above right); in conjunction with the presence of ornamental arabesques, they suggest an affinity with the decorative linearity of Art Nouveau. The careful bal-

Special No. 21, 1916
Oil on cardboard, 34 x 41 cm
Santa Fe (NM), Museum of New Mexico

"The abstract artist receives his inspiration not from any piece of nature you please, but from Nature as a whole, from its most multifarious manifestions, which accumulate in him and lead to the work of art."
WASSILY KANDINSKY, *Concerning the Spiritual in Art, 1912*

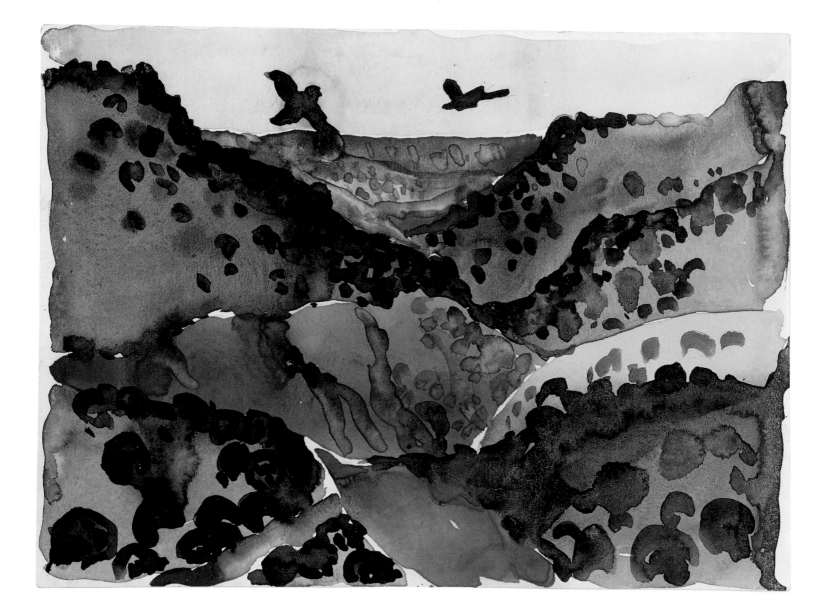

Canyon with Crows, 1917
Watercolour, 22.9 x 30.5 cm
© Juan Hamilton

In contrast to Europe, where a picture of un-spoiled nature could only be obtained by with-drawing into an artists' colony, the notion of vir-gin territory and "new frontiers" was part of the identity of American art.

ance of light and shade points to the Japanese *notan* system of composition championed by Dow, which emphasizes the importance of the relationship between light and dark for the significance of the composition. The rhyth-mic, almost musical element in these drawings also recalls another of Dow's theories, namely that music, the fine arts, architecture and poetry all share the same fundamental principle of rhythmic repetition. In the case of paint-ing, this principle signifies the repetition of successive lines, which produces a harmonious overall effect.

In the early summer of 1916 – without notifying O'Keeffe – Stieglitz ex-hibited the *Special* series in "291", along with the work of two other artists. Influenced by the theories of Sigmund Freud and his analyses of the uncon-scious and sexuality, Stieglitz interpreted the flowing lines of O'Keeffe's charcoal drawings as the expression of feminine intuition.

In autumn that same year O'Keeffe took up a new teaching post in Canyon, Texas. Stieglitz sent her the latest issues of his gallery journal; O'Keeffe re-plied with a new series of watercolours produced after excursions into the surrounding Texan plains. Canyons and magnificent light effects are sum-marized in large planes of colour, as for example in *Red Mesa* of 1917 (p. 13), pointing to a spontaneous, emphatically emotional translation of the motif. While the style is still largely naturalistic, the exaggerated, kaleido-scopic palette allows us to sense the intensity of the artist's experiences in

ABOVE:
Red Mesa, 1917
Watercolour, 22.9 x 30.5 cm
© Juan Hamilton

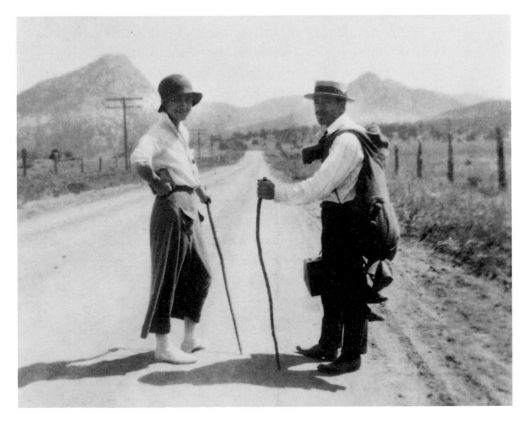

13

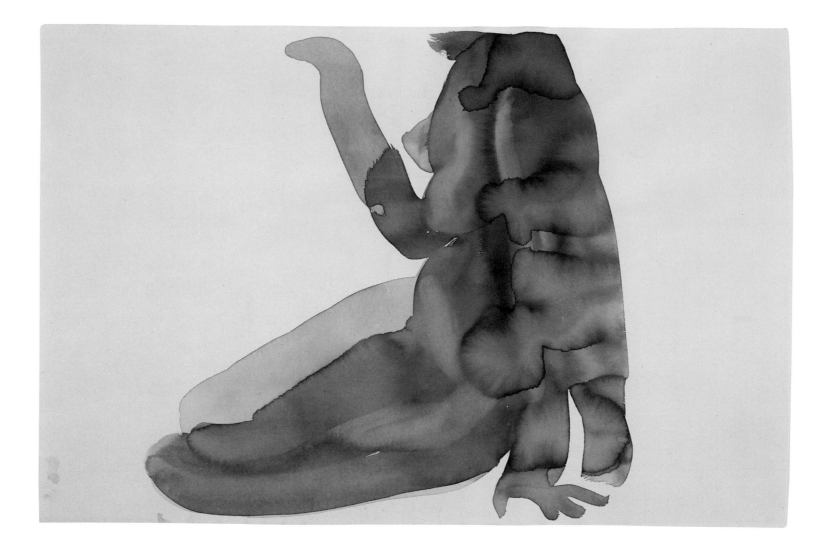

Nude Series XII, 1917
Watercolour, 30.5 x 45.7cm
Abiquiu (NM), The Georgia O'Keeffe Foundation

ILLUSTRATION PAGE 15:
Nude Series VIII, 1917
Watercolour, 45.7 x 34.3cm
Abiquiu (NM), The Georgia O'Keeffe Foundation

In the watercolours of her *Nude Series*, Georgia
O'Keeffe reviews the exercises in life drawing
which she executed at the Art Institute of Chi-
cago. The studies, for which one of her friends
sat as model, recall Auguste Rodin, whose draw-
ings O'Keeffe had seen in exhibitions at Stieg-
litz' "291" gallery. Rodin was the first to attempt
to render the naked body in motion. Here, over-
lapping and merging areas of colour also lend
O'Keeffe's figures an element of dynamism and
vitality.

the prairie landscape. In 1917 Stieglitz dedicated a one-woman-show to
O'Keeffe; it would be the final exhibition in "291", since the building was
due to be demolished. At the last minute, O'Keeffe decided to travel to New
York. There, Stieglitz photographed her for the first time, portraying the ar-
tist in front of her pictures. Their continuing correspondence and Stieglitz'
support gave O'Keeffe the courage she needed to give up teaching and
devote herself exclusively to painting. In June 1918 she turned her back on
Texas and moved to New York.

Through her combination of profound intuition with a clear capacity for ab-
straction, Georgia O'Keeffe created a repertoire of geometric and organic
forms which swept her to a high point in an artistic career which had barely
yet begun. Over the following decades she would draw again and again
upon this discriminating formal vocabulary.

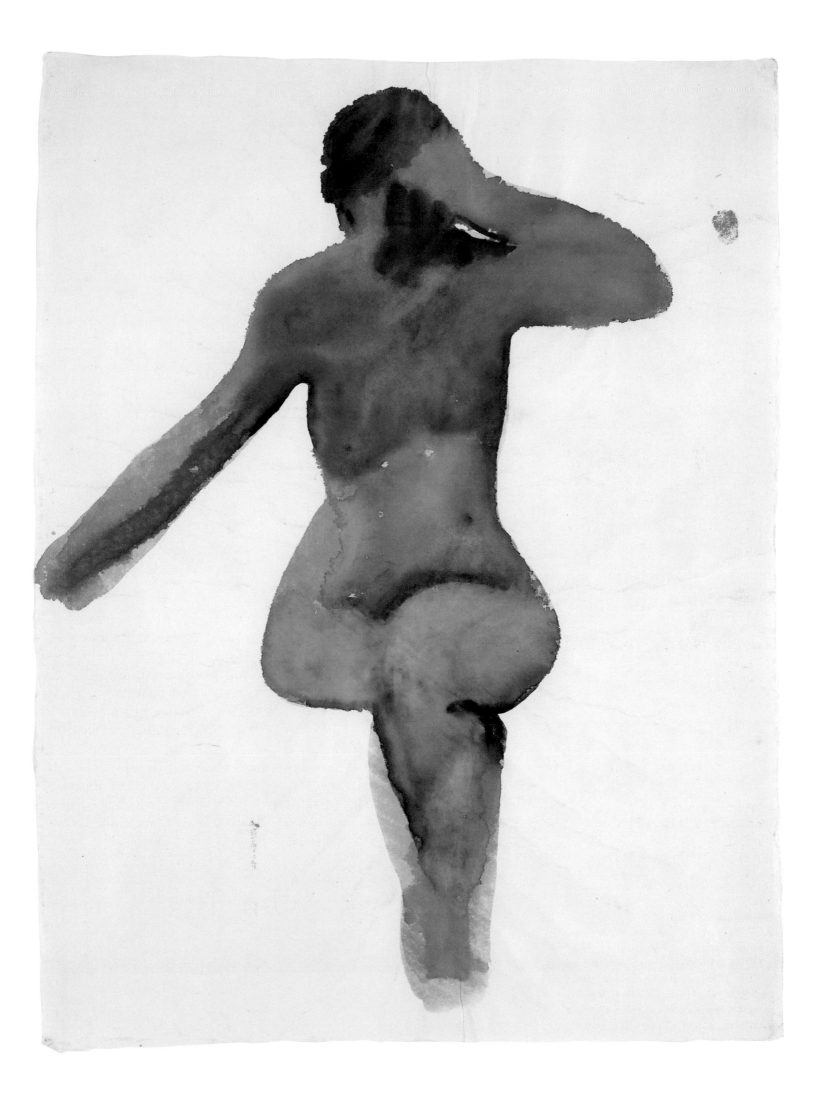

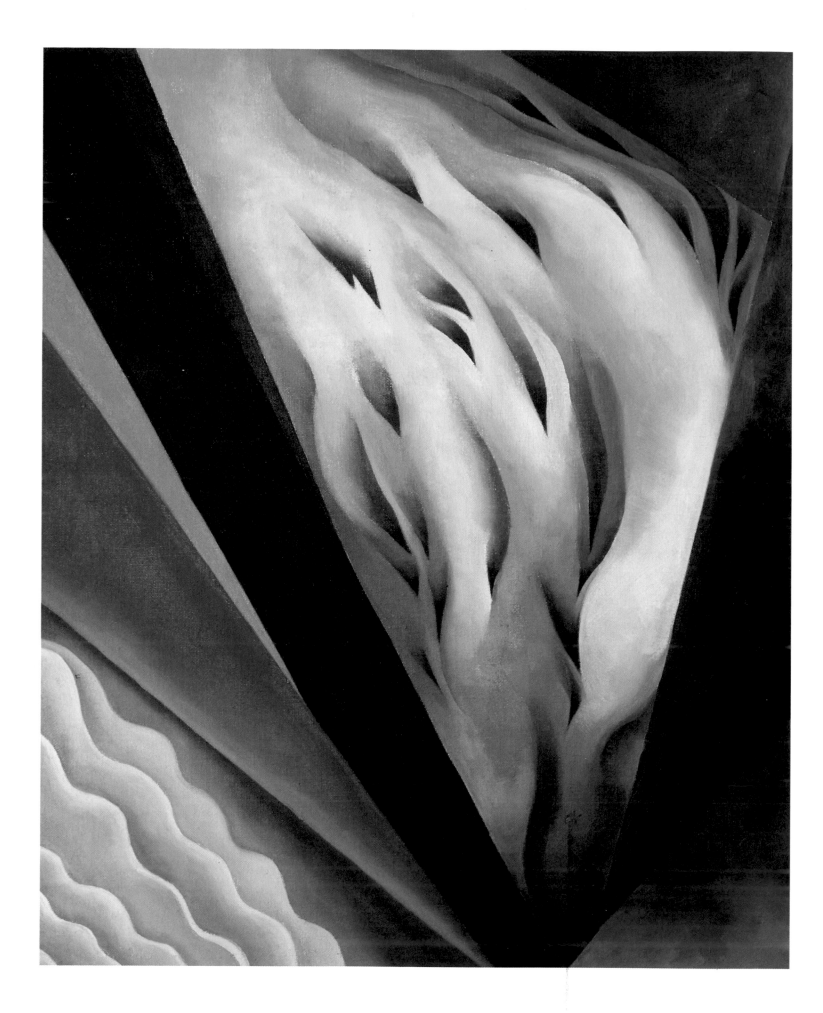

The circle of artists around Alfred Stieglitz

In New York, O'Keeffe lived first in a small studio belonging to Stieglitz' niece. Here Alfred Stieglitz began to photograph her intensively, and it was not long before he moved in with her, having finally abandoned his unhappy marriage. Their feelings for one another knew no bounds: "We have talked over practically everything. Into one week we have compressed years – I don't think there has ever been anything to equal it," wrote Stieglitz to his sister. In Georgia – 23 years his junior – Stieglitz found a new source of inspiration for his photography. He made studies of her feminine body, the texture of her skin, her prominent cheek bones and, over and over again, her beautiful, slender hands. Not a contour or an angle escaped the admiring lens of Stieglitz' camera.

Over the years from 1917 to 1937, Stieglitz proceeded to compile a photographic portrait of O'Keeffe which, like a mosaic, captures ever different facets of her personality in changing settings, angles and lighting. Many years later, O'Keeffe recalled: "His idea of a portrait was not just one picture. His dream was to start with a child at birth and photograph that child in all of its activities as it grew to be a person and on throughout its adult life. As a portrait it would be a photographic diary." In comparison to the photographs taking during the early years of their relationship, 1918 to 1922, when Stieglitz focused his camera in close-up on O'Keeffe's body, he later adopted a more holistic approach, emphasizing her whole being.

Since the age of twenty, Alfred Stieglitz had devoted his life to artistic photography and – later – also to contemporary art. At his side, O'Keeffe was now introduced to the artists, writers, critics and photographers at the forefront of the avant-garde art scene in New York. During Stieglitz' early years as gallery-owner of "291" he had championed a European modernism, but towards the end of the First World War he turned exclusively to American art. It became his mission to propagate an artistic form of expression which was independent of European influences. This was best achieved, he believed, through the medium of a small group of artists. Orbiting in this sphere around Stieglitz were the painters Arthur Dove (1880–1946), Marsden Hartley (1877–1943), John Marin (1870–1953) and Charles Demuth (1883–1935), the photographer Paul Strand (1890–1976) and Georgia O'Keeffe. In his galleries – or "laboratories", as he liked to call them –, which after "291" included first "The Intimate Gallery", opened in 1925, and later "An American Place", Stieglitz fought for the recognition of the artist in society.

Of the artists in her immediate environment, O'Keeffe felt herself drawn most strongly to Arthur Dove. Influenced by the theories of the French philosopher Henri Bergson (1859–1941) and his emphasis upon intuition, Dove

Alfred Stieglitz:
Mountains and Sky, Lake George, 1924
Gelatin silver print
Philadelphia (PA), Philadelphia Museum of Art:
Given by Carl Zigrosser

ILLUSTRATION PAGE 16:
Blue and Green Music, 1919
Oil on canvas, 58.4 x 48.3 cm
Chicago (IL), The Art Institute of Chicago,
Alfred Stieglitz Collection, Gift of Georgia
O'Keeffe, 1969.835

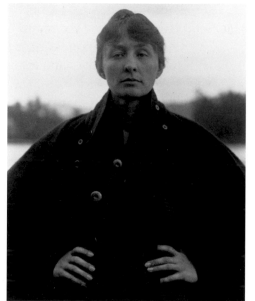

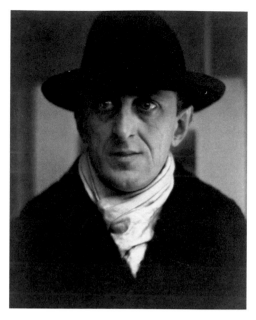

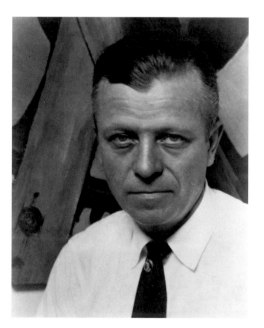

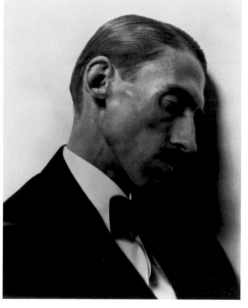

ABOVE LEFT:
Alfred Stieglitz:
Self-portrait
Gelatin silver print
Philadelphia (PA), Philadelphia Museum of Art:
From the Collection of Dorothy Norman

ABOVE CENTRE:
Alfred Stieglitz:
Georgia O'Keeffe, 1918
Gelatin silver print
Philadelphia (PA), Philadelphia Museum of Art:
Purchased: Lola Dowin Peck Fund

ABOVE RIGHT:
Alfred Stieglitz:
Marsden Hartley, 1915
Platinum print
Philadelphia (PA), Philadelphia Museum of Art:
Alfred Stieglitz Collection

BELOW LEFT:
Alfred Stieglitz:
Arthur G. Dove, 1915
Photograph
Philadelphia (PA), Philadelphia Museum of Art:
From the Collection of Dorothy Norman

BELOW CENTRE:
Alfred Stieglitz:
Charles Demuth, 1922
Gelatin silver print
New York, The Museum of Modern Art. Gift of
Samuel M. Kootz

BELOW RIGHT:
Albert E. Gallatin:
John Marin
Photograph
Philadelphia (PA), Philadelphia Museum of Art:
The A.E. Gallatin Collection

had arrived at an abstract vocabulary based on elementary forms of nature. Intuition, a factor which was accorded great significance amongst the members of Stieglitz' circle, finds particular – and at times similar – expression in the works of Dove and O'Keeffe. Georgia admired the simplicity and the close connection with nature expressed in Dove's art, and she was one of the first to purchase his pictures. O'Keeffe also felt an aesthetic affinity with Charles Demuth. Both artists shared a love of fruits and flowers, which Demuth portrayed in sensual watercolours. Indeed, the two regularly talked about collaborating on a large flower painting.

In her early New York years, O'Keeffe – now working in oils – continued her abstractive landscapes. Like Marsden Hartley and Arthur Dove, she also began to explore the analogies between painting and music. For O'Keeffe, throughout her life, music reigned supreme amongst the arts. At Columbia Teachers College, she had watched with fascination as Alon Bement, following Dow's principles, put on a piece of music and instructed his students to express in drawings the abstract sound patterns they were hearing. Dow saw the abstract content of music as the perfect model for non-representational art, and O'Keeffe took up her teacher's ideas in a number of her own canvases of 1919. By this time she had also been introduced to the luminous abstract paintings of Synchromist Stanton MacDonald Wright, which she greeted with enthusiasm.

O'Keeffe's reponses to music are symphonies in pink and blue (p. 21) and blue and green (p. 16). Her colours are delicately coordinated and at the same time boldly orchestrated to achieve maximum expressiveness, as if they thereby wish to give voice to the entire emotional spectrum of the "inner sonority" of painting. While the palette of these pictures derives from the artist's imagination, the forms still remain related, however loosely, to natural appearances.

Stieglitz, who had no gallery of his own between 1917 and 1925, arranged to have an exhibition of his works in the Anderson Galleries in 1921. Half of the photographs on display were studies of O'Keeffe, many of them intimate nudes. As a result, she found herself thrust her into the limelight as Stieglitz' model and muse, and not as an artist in her own right. In an essay published that same year, Marsden Hartley also became the first to draw public attention to what he identified as the sexual aspects of O'Keeffe's art – an interpretation first voiced by Stieglitz. O'Keeffe, who found Hartley's suggestions ridiculous, was deeply hurt by the essay. "I almost wept," she confessed. "I thought I could never face the world again."

In 1923 Stieglitz mounted another exhibition in the Anderson Galleries, this time dedicated to O'Keeffe – her second solo show. The image of an unconventional and uninhibited woman artist created by Stieglitz' exhibition two years previously had left an enduring impression, and the critics now interpreted O'Keeffe's painting in a corresponding light. The exhibition proved a powerful magnet, drawing large numbers of visitors, and made O'Keeffe a celebrity in New York. Her popularity was thus founded not least on her reputation as an unusual woman who did not match the stereotype of her day. The artists in Stieglitz' circle often spent the summer months at Lake George in the Adirondack Mountains, where Stieglitz' family owned a large house directly overlooking the lake. Stieglitz and O'Keeffe spent their summers there regularly from 1918 onwards, and it was here that O'Keeffe did most of her painting. The couple would frequently only return to New York in November. The artist, who had personally converted a dilapidated hut into a studio which she called "The Shanty" (p. 27), and the photographer shared the sources of inspiration which surrounded them at

Charles Demuth:
Poster Portrait: Georgia O'Keeffe, 1923
New Haven (CT), Courtesy of Beinecke Rare Book and Manuscript Library, Yale University Library

Paul Strand:
Abstraction, Bowls, Twin Lakes, Connecticut, 1916
Photograph
Millerton, © 1971, Aperture Foundation Inc., Paul Strand Archive

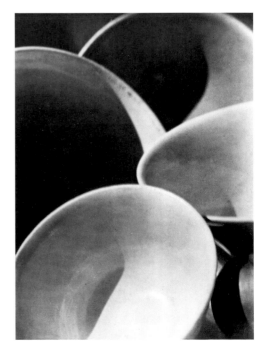

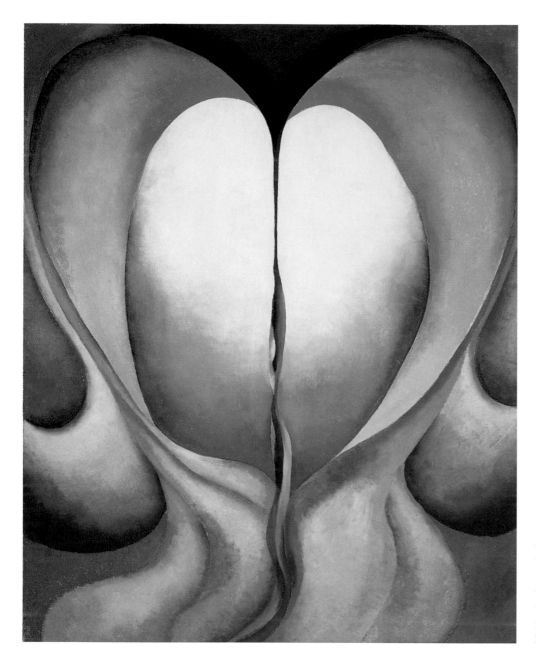

Series I, No. 8, 1919
Oil on canvas, 50.8 x 40.6 cm
Abiquiu (NM), The Georgia O'Keeffe Foundation

"What is right artistically can only be attained through feeling […]. Even if overall construction can be arrived at purely by theory, nevertheless there remains something extra, which is the true spirit of creation […], which can never be created or discovered through theory, but only suddenly inspired by feeling." It was Alon Bement who recommended Georgia O'Keeffe to read *Concerning the Spiritual in Art*, shortly after it was translated into English in 1914. Kandinsky's words must have spoken clearly to the young artist, who sought to express in her own painting her emotional experience of a subject.

Lake George – the lake, the sky, the clouds, the nearby mountains, the farmhouse and the barns. They exchanged ideas: in the series of cloud studies which Stieglitz photographed in 1922, for example, he referred back to the abstractions derived from natural forms which Georgia O'Keeffe had executed the year before.

While Stieglitz, in his photographs, was emphasizing the abstract quality of nature, O'Keeffe was increasingly turning her attention to the representational world. The portraits Stieglitz had taken of her had not been without influence upon her painting. From the first moment onwards, O'Keeffe fell in love with these unusual photographs of herself. This fascination with her mirror image was seized upon by other famous photographers, amongst them Ansel Adams, Arnold Newman, Philippe Halsman and Yosuf Karsh, who made her one of the most photographed women in the world.

In soft modulations of light and dark and an endless number of shimmering shades, Stieglitz' masterly deployment of light reveals the substance and substantiality of O'Keeffe's body in a manner normally withheld from the eye (p. 31). "I can see myself [in Stieglitz' photographs]," she acknowledged, "and it has helped me to say what I want to say – in paint." O'Keeffe's aes-

ILLUSTRATION PAGE 21:
Music – Pink and Blue II, 1919
Oil on canvas, 88.9 x 74 cm
New York, Collection of Whitney Museum of American Art. Gift of Emily Fisher Landau in honor of Tom Armstrong

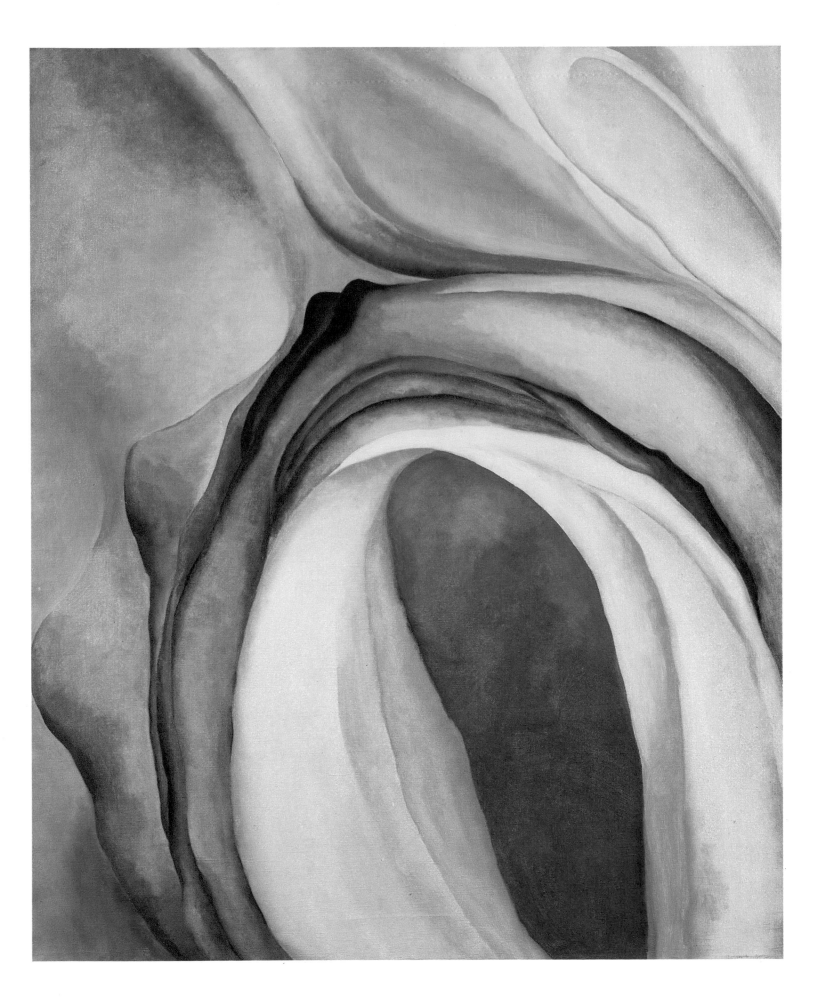

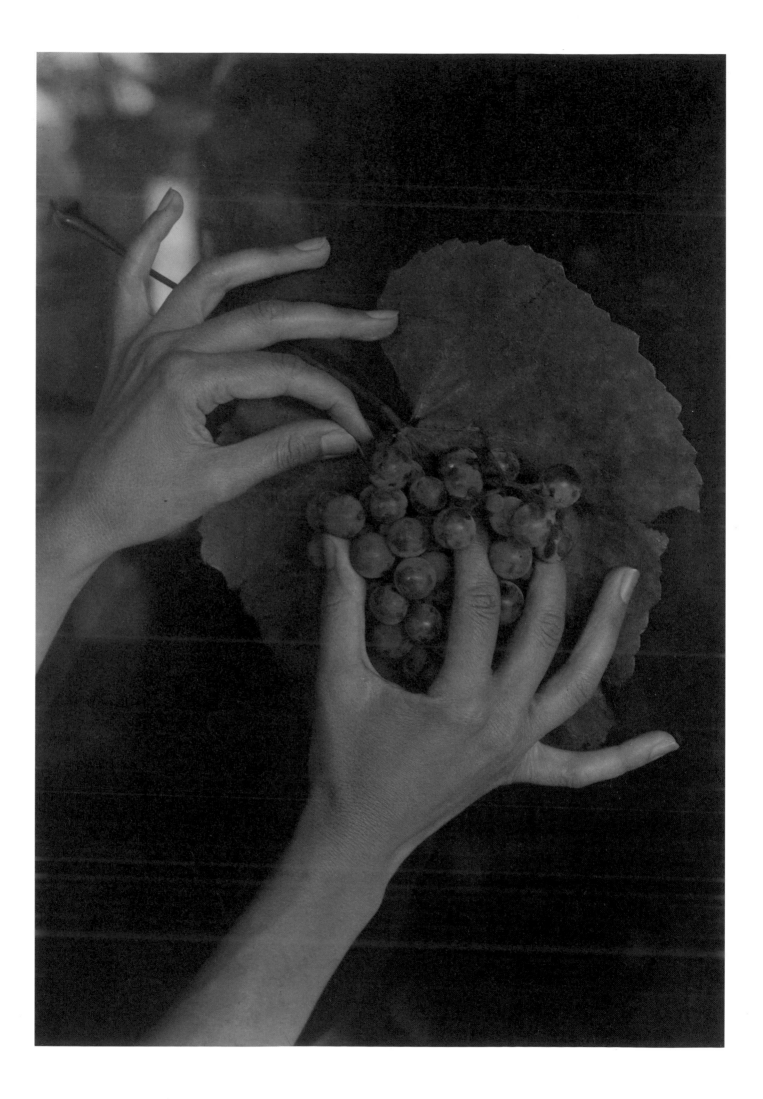

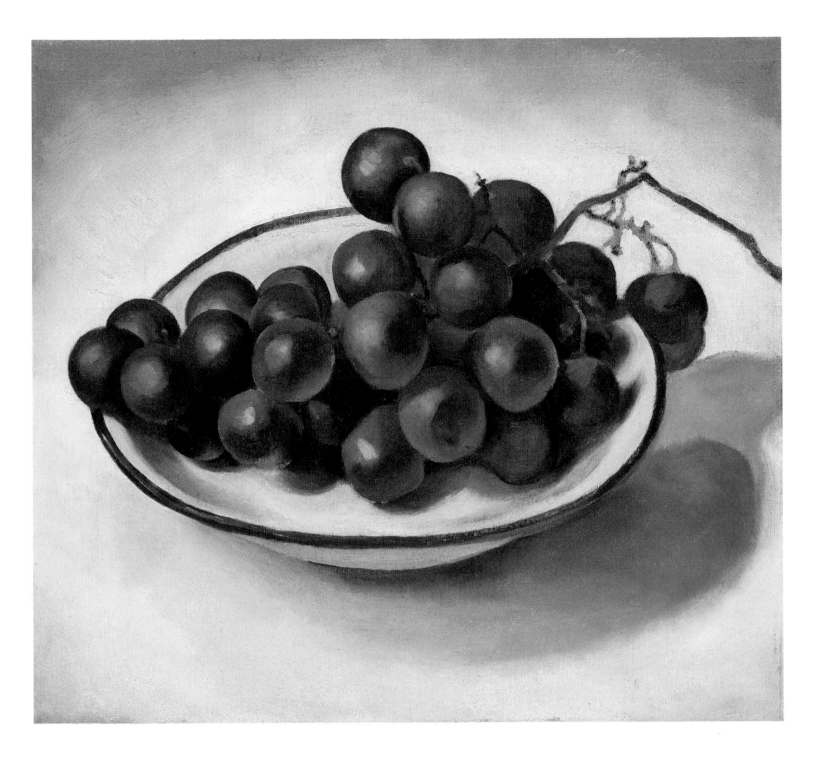

thetic aims as a painter were fully in accord with those of her photographer contemporaries, for whom the goals of the photography to which they aspired – and which they called "pure photography" – were epitomized in careful composition, perfect lighting, precision of focus and the outstanding quality of the final print.

In the work of the young photographer Paul Strand, which she first saw in 1917, O'Keeffe had already encountered one particular aspect of photography that would enthral her. Influenced by trends in Cubist painting, Strand photographed familiar objects from very close up, in a corresponding light. The resulting effect of magnification dissolved the realistic forms into an almost abstract composition of geometric organizations (p. 19, below). Strand's revolutionary notion of applying the laws of abstract painting to the medium of photography aroused O'Keeffe's interest. She wrote enthusiastically to Strand: "I believe Ive [sic] been looking at things and seeing them as I thought you might photograph them –Isn't that funny – making Strand

Grapes on White Dish – Dark Rim, 1920
Oil on canvas, 22.9 x 25.4 cm
Santa Fe (NM), Collection Mr and
Mrs J. Carrington Woolley

ILLUSTRATION PAGE 22:
Alfred Stieglitz:
Georgia O'Keeffe: A Portrait – Hands and Grapes, 1921
Palladium photograph
Washington (DC), Alfred Stieglitz Collection,
© 1994 National Gallery of Art

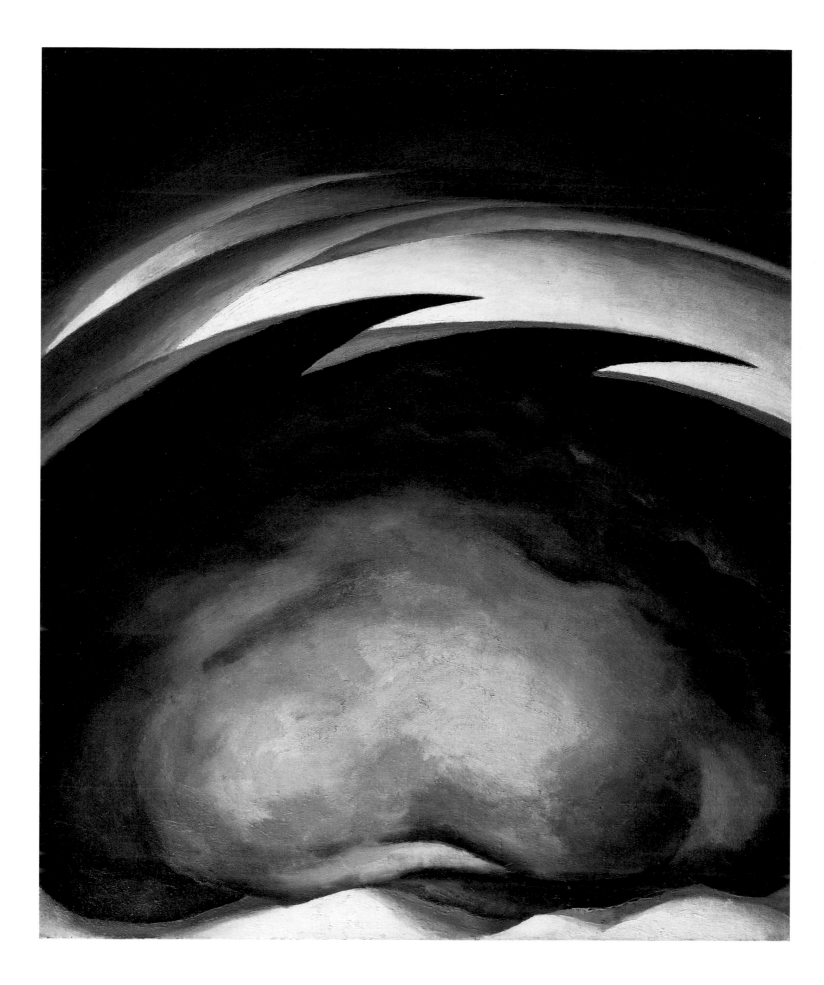

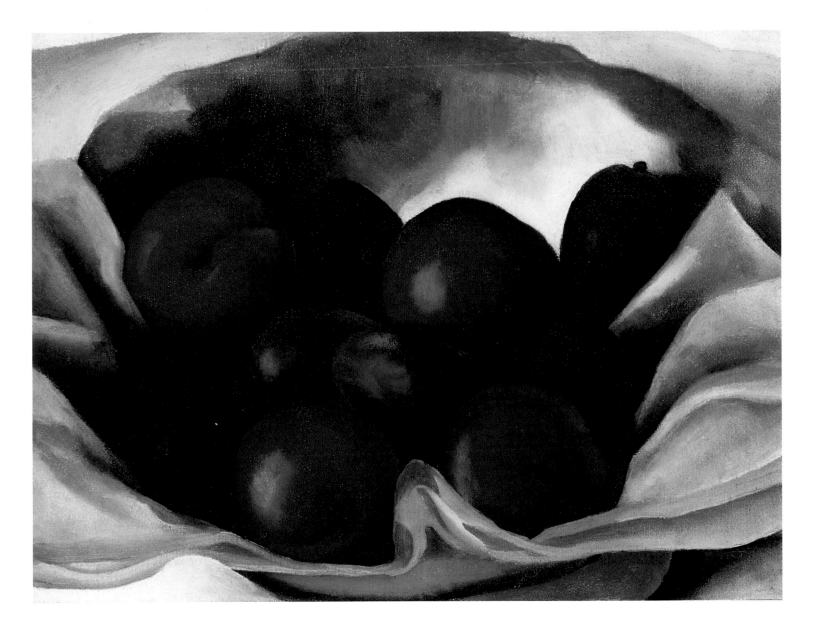

photographs for myself in my head. […] I think you people have made me see – or should I say feel – new colors – I cannot say them to you but I think Im [sic] going to make them."

The trend towards a new objectivity in art at the start of the twenties was another international phenomenon which did not leave American artists such as O'Keeffe and Hartley untouched. In O'Keeffe's ostensibly naturalistic still life *Plums* of 1920 (p. 25), the fruits are presented temptingly close to the viewer. The composition is cropped by the edges of the canvas, like a trimmed photograph. Each individual plum is almost tangible in its full volume and material texture. True-to-life realism is not, however, the artist's aim. Thus, although subtly modelled, the fruits are rigorously simplified and pared down to their essentials. To the same degree that O'Keeffe reduces the representational accuracy of the plums, she amplifies their colour, intensifying it above and beyond natural appearances. Through magnification of her subject – a trick which will become an essential characteristic of her art – O'Keeffe immediately frees herself from all obligation to the traditional still-life format.

Like Georgia O'Keeffe, Stieglitz and his friends were strongly influenced by Kandinsky's theories and painting. Similarly, the notion that a work of art can provide a visual "equivalent" of how the artist perceives and experiences life – a theory which had arisen out of Symbolism – also played an im-

Plums, 1920
Oil on canvas, 22.9 x 30.5 cm
Boston (MA), Collection of Paul and Tina Schmid

ILLUSTRATION PAGE 24:
From the Plains I, 1919
Oil on canvas, 70.1 x 65 cm
Collection A. Crispo

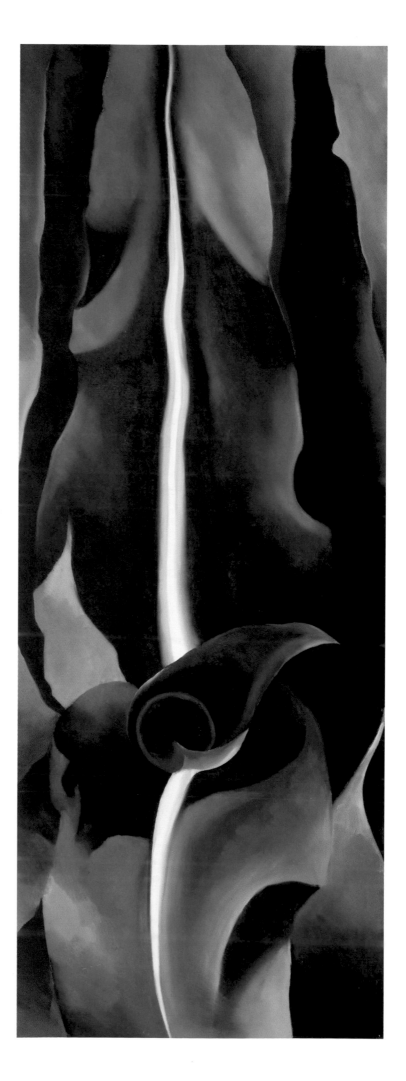

Corn, Dark I, 1924
Oil on cardboard, 80.6 x 30.2 cm
New York, The Metropolitan Museum of Art,
Alfred Stieglitz Collection, 1950

My Shanty, Lake George, 1922
Oil on canvas, 50.8 x 68.6cm
Washington (DC), © The Phillips Collection

"Intuition," wrote the French philosopher Henri Bergson (1859–1941), "is a method of feeling one's way intellectually into the inner heart of a thing, in order to locate what is unique and inexpressible in it. If there is a way of grasping a reality in absolute rather than relative terms, of entering into it rather than taking up positions on it, of comprehending it without any translation or symbolism, then that way is metaphysics itself." Bergson's philosophy was of pivotal significance for art and literature around the turn of the century. To place oneself inside reality rather than occupy a standpoint outside it was also Georgia O'Keeffe's intention: here, waves of water and air breaking over each other offer an insight into the universal reality of Creation.

portant role within the circle. Starting from their common respect for nature and the American landscape, the artists were all searching for a form of expression through which they could reproduce their experiences of nature. Thus O'Keeffe wrote to William Milliken, director of the Cleveland Art Museum, in 1930: "I know I can not paint a flower. I can not paint the sun on the desert on a bright summer morning but maybe in terms of paint color I can convey to you my experience of the flower or the experience that makes the flower of significance to me at that particular time."

In the view of the artists, this translation of experience into art is not tied to representational form, but may equally well be expressed in abstract terms. The determining factor in this respect is the depth of feeling triggered by the experience of reality. For O'Keeffe, whose pictorial language comprises a harmonious synthesis of abstraction and objectivity, abstract representation frequently provides the means of coming closest to the truth she seeks to express: "It is surprising to me to see how many people separate the objective from the abstract. Objective painting is not good painting unless it is good in the abstract sense. A hill or tree cannot make a good painting just because it is a hill or a tree. It is lines and colors put together so that they say something. For me that is the very basis of painting. The abstraction is often the most definite form for the intangible thing in myself that I can only clarify in paint." Between the artists of Stieglitz' circle, there existed a fundamental affinity which expressed itself above all through an idealizing vision of nature and a self-identification with the vastness of the American landscape. This affinity extended to O'Keeffe, too, drawing her into the process of mutual influence and inspiration within the circle. Although by no means always obvious at a formal level, this influence would lead O'Keeffe to make further, similar emotional statements, which would in turn give a new direction to her art.

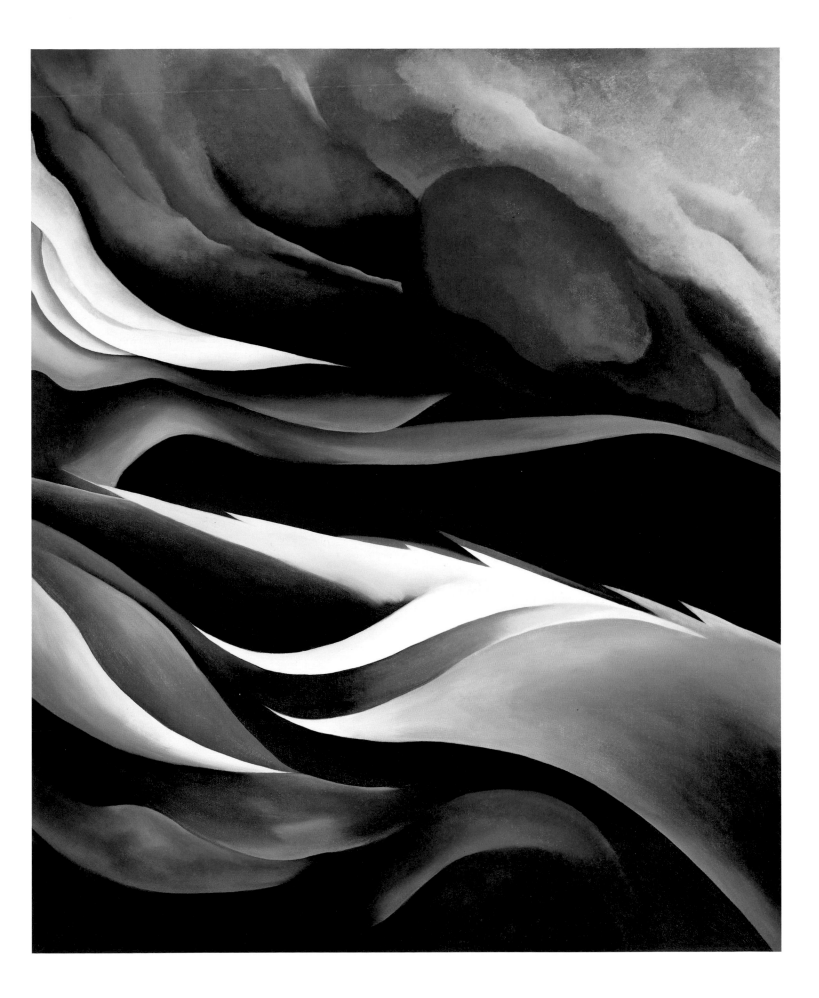

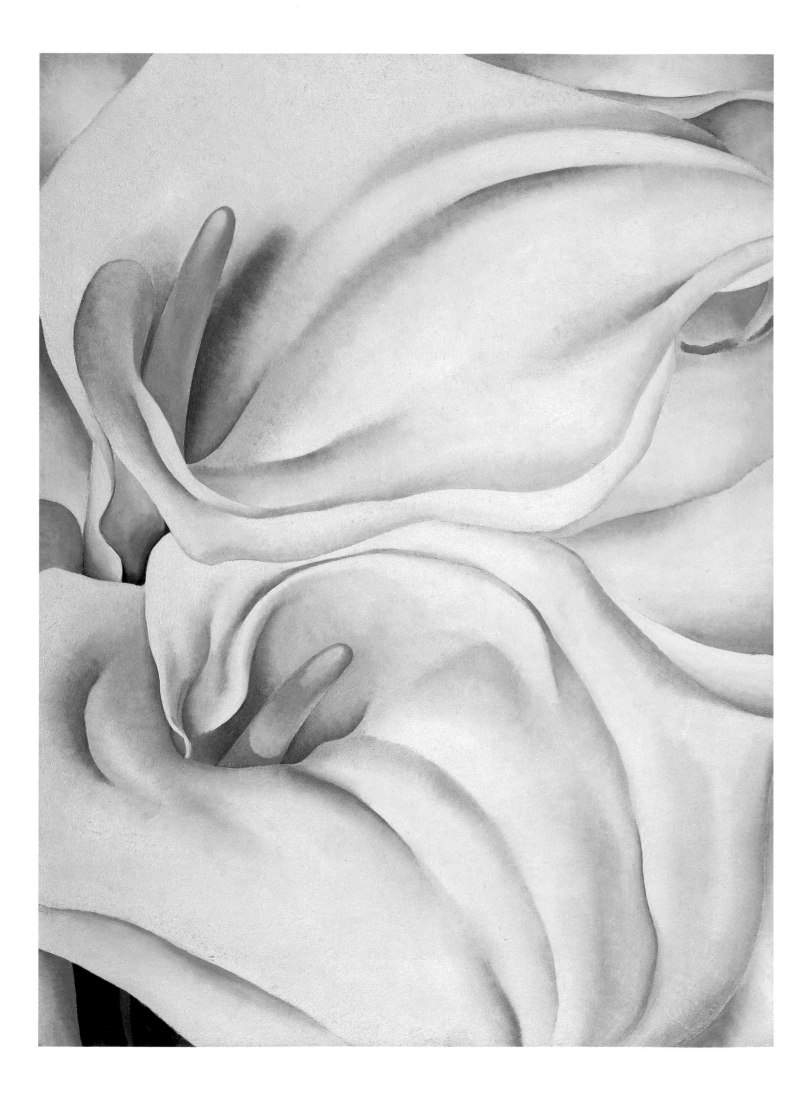

Flowers and skyscrapers

Georgia O'Keeffe's art was always an immediate response to her environment. Alongside portraits of the landscape around Lake George, her work from the early 1920s onwards was dominated by still lifes of flowers and canvases of New York City. O'Keeffe had been fascinated by the microcosm of a flower ever since her schooldays in Madison, where her art teacher had brought a jack-in-the-pulpit into the classroom for the pupils to study. O'Keeffe had begun painting flowers in 1918, but it was not until 1924, the year in which she and Stieglitz were married, that she produced the first of the magnified flowers with which she is most frequently associated, and which have come to represent a hallmark of her œuvre. It was the sight of a tiny flower in a still life by Fantin-Latour that prompted her to adopt a magnified perspective: "A flower is relatively small. Everyone has many associations with a flower – the idea of flowers. […] Still – in a way – nobody sees a flower – really – it is so small – we haven't time – and to see takes time, like to have a friend takes time. […] So I said to myself – I'll paint what I see – what the flower is to me but I'll paint it big and they will be surprised into taking time to look at it – I will make even busy New Yorkers take time to see what I see of flowers."

In 1925 a number of her paintings were included in the "Seven Americans" show organized by Stieglitz in the Anderson Galleries. Exhibited alongside works by Marin, Demuth, Hartley, Dove, Strand and Stieglitz, they drew an enthusiastic response from the public. In the period from 1918 to 1932 O'Keeffe produced more than 200 flower paintings, in which common flowering plants such as roses, petunias, poppies, camelias, sunflowers, bleeding hearts and daffodils are accorded the same significance as rare blooms such as black irises and exotic orchids. One of the flowers that she regularly treated in larger-than-life format was the calla lily. This subsequently became her "emblem" in the eyes of the public, and one which the Mexican artist Miguel Covarrubias took up in his caricature of O'Keeffe as "Our Lady of the Lily", which appeared in the *New Yorker* in 1929 (p. 32). Calla lilies had first caught the artist's eye in a florist's shop at Lake George: "I started thinking about them because people either liked them or disliked them intensely, while I had no feeling about them at all."

In O'Keeffe's flower paintings, as typified by *Two Calla Lilies on Pink* of 1928 (p. 30), the entire canvas is usually filled by just one or two blooms. These are painted in extreme close-up, as a result of which the outer edges of the leaves and stems are often cut off. The larger picture must thus be completed in the viewer's mind. Through their magnification, the flowers are taken out of their natural context and acquire a special, outsized significance. The close-up angle permits a detailed examination of the individual

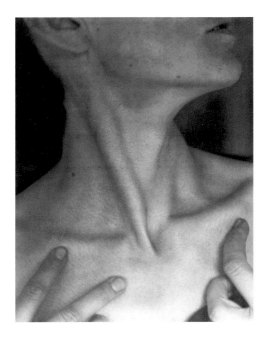

Alfred Stieglitz:
Georgia O'Keeffe: A Portrait – Neck, 1921
Gelatin silver print
Santa Fe (NM), Collection of Hanna and Manfred Heiting, Courtesy of Gerald Peters Gallery

ILLUSTRATION PAGE 30:
Two Calla Lilies on Pink, 1928
Oil on canvas, 101.6 x 76.2 cm
Philadelphia (PA), Philadelphia Museum of Art:
Alfred Stieglitz Collection, Bequest of Georgia O'Keeffe

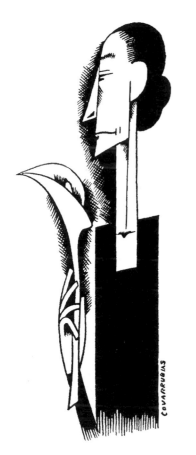

Miguel Covarrubias:
Our Lady of the Lily: Georgia O'Keeffe, 1929
© 1929, 1957. Courtesy of the New Yorker
Magazine Incorporated

ILLUSTRATION PAGE 33:
Single Lily with Red, 1928
Oil on wood, 30.5 x 15.9cm
New York, Collection of Whitney Museum of
American Art. Purchase

The magnified head of a single calla lily, here
particularly emphasized by its setting against a
plain red background, was one of O'Keeffe's
favourite flower motifs. Over the course of the
1920s it became a sort of emblem of her art.

ILLUSTRATION PAGE 34:
White Iris, c. 1926
Oil on canvas, 61 x 50.8cm
New York, Collection Emily Fisher Landau

ILLUSTRATION PAGE 35:
Light Iris, 1924
Oil on canvas, 101.6 x 76.2cm
Richmond (VA), Virginia Museum of Fine Arts,
Gift of Mr and Mrs Bruce C. Gottwald

structure of each bloom. O'Keeffe's flowers are no artifical creations; in these paintings, the waxy texture of a lily is described with the same painstaking care as the velvety fibrillation of an iris. The resulting impression of physical solidity and durability is reinforced by the artist's application of her paint in dense, invisible brushstrokes. O'Keeffe, who always aspired to technical perfection, also employed a special primer in order to create a smooth ground, in combination with a very fine grade of canvas.

At the same time, however, she is concerned in her flower paintings with formal simplification. This may be this reason why the calla lily – a flower fascinating for its structural simplicity – was one of her favourite subjects. Her portrayals of flowers, which she always leaves in their local colours, are simultaneously descriptions of single colours, as indicated by their titles, which refer to red poppies and black irises. In order to make a closer study of blue, for a while O'Keeffe grew a bed of purple petunias in the garden at Lake George.

She described her feelings about colour, which she considered her most important means of expression all her life, in a letter to William Milliken: "The large White Flower with the golden heart is something I have to say about White – quite different from what White has been meaning to me. Whether the flower or the color is the focus I do not know. I do know that the flower is painted large to convey to you my experience of the flower – and what is my experience of the flower if it is not color. […] Color is one of the great things in the world that makes life worth living to me and as I have come to think of painting it is my effort to create an equivalent with paint color for the world – life as I see it."

As with other subjects in her œuvre, O'Keeffe made a number of these flowers the objects of a series of paintings, seeking to refine the motif in each fresh version. The series was a concept she pursued throughout her career, and suggests a parallel with Japanese art, in which the same subject is similarly treated again and again in new variations, from various angles, and at different times of the year. O'Keeffe did not thereby remain bound to a representational style of painting, however. In the *Jack-in-the-Pulpit* series (pp. 42–45), for example, she moves in a succession of six canvases ever further towards abstraction. Nowhere in her œuvre is she closer to her ideal of reaching the essence via the simplification of form than in this series. By the final canvas, all that remains of the relatively realistic, albeit simplified representation of the first jack-in-the-pulpit is its characteristic stamen.

The magnification O'Keeffe introduced into her flower paintings is diametrically opposed to the format traditionally employed in flower still lifes. Her close-up views of flowers, presented as if from the perspective of a butterfly or a bee, can best be compared with close-up photography, such as the pictures of a waterlily taken by Edward Steichen ten years earlier. Although O'Keeffe, like other artists, disputed the influence of other people's work on her art, her outsized flowers – like the fruit still lifes of the preceding years – suggest a link with the enlargements in the photographs by Paul Strand, which she had seen for the first time in 1917. O'Keeffe's innovative magnifications on canvas arose at the same time as the sensual, close-up photographs of flowers and natural objects being taken not just by Paul Strand, but also, on the east coast of America, by Imogen Cunningham and Edward Weston.

The grace and charm exuded by O'Keeffe's flowers may be seen as an expression of her great love for the plant world. Her respect for the life of the individual flower was similarly reflected in her behaviour: on one occasion,

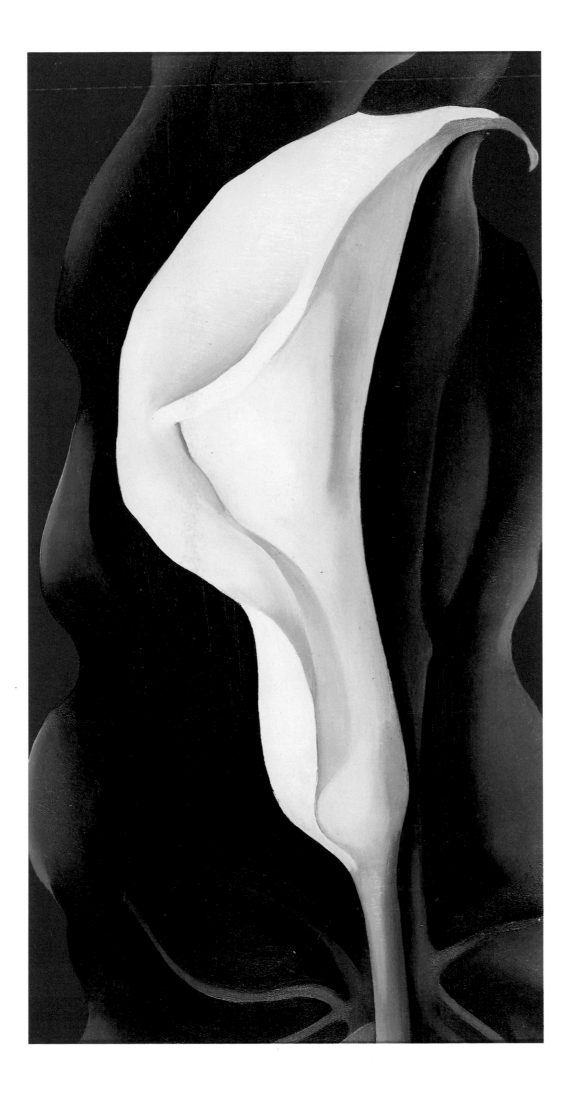

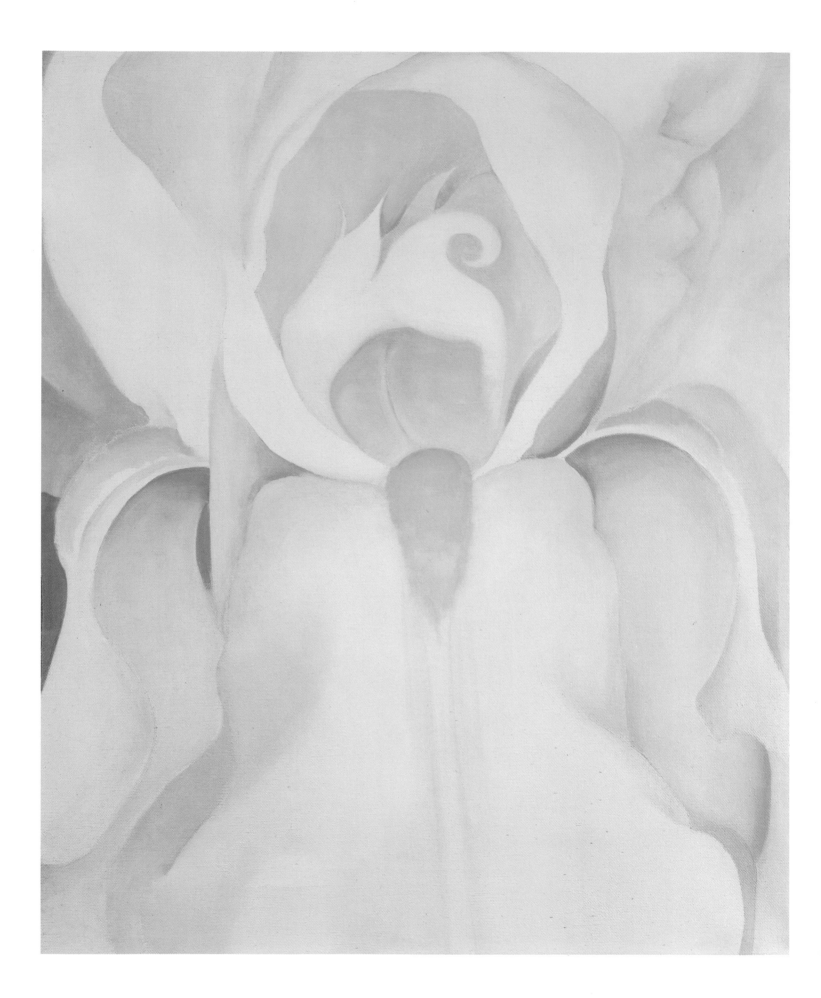

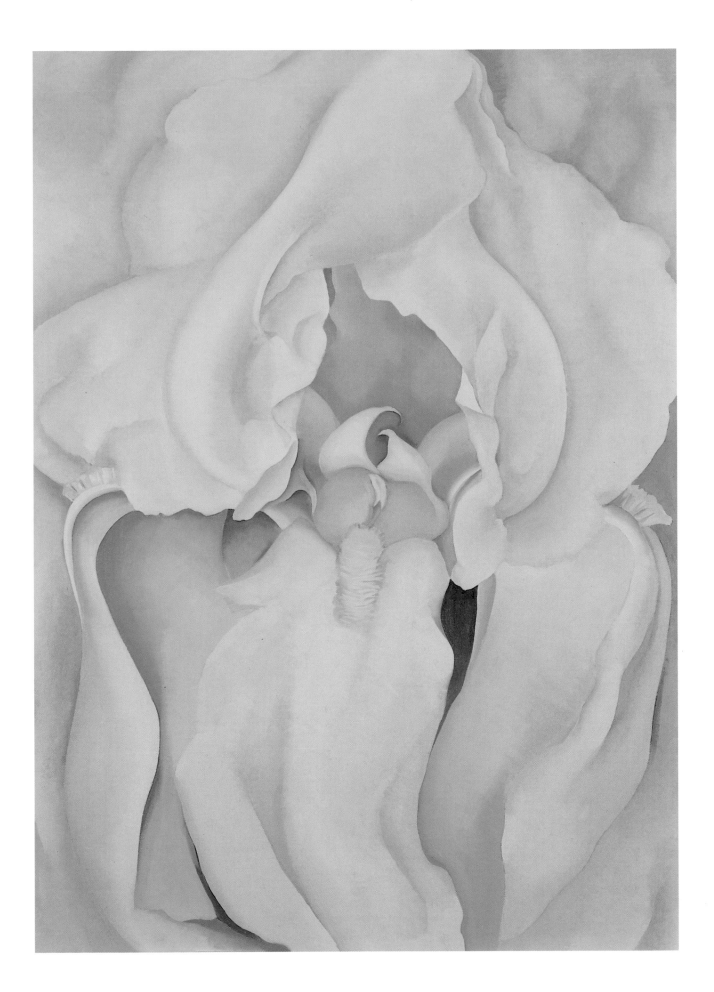

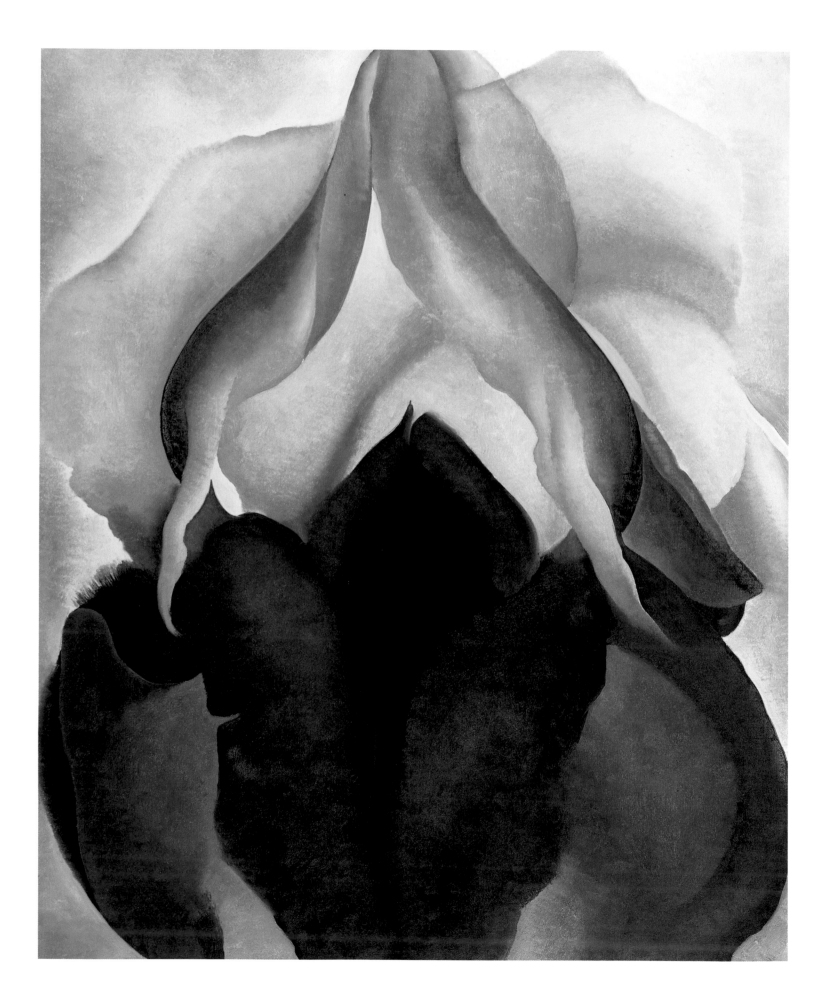

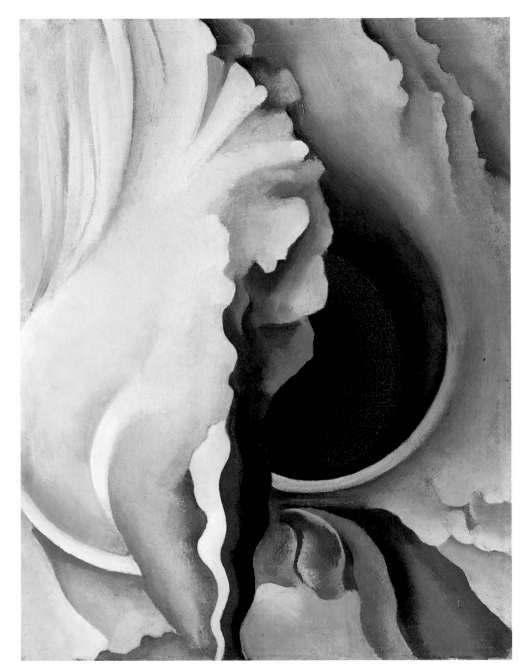

The Dark Iris No. II, 1926
Oil on canvas, 22.9 x 17.8 cm
Abiquiu (NM), The Georgia O'Keeffe Foundation

"I believe a leaf of grass is no less than the journey-work of the stars," wrote the celebrated American poet Walt Whitman (1819–1892). Whitman's *Leaves of Grass* established the distinctive characteristics of the American appropriation of reality: an immediate proximity to the phenomena of nature, a stylization of their beauty and a literal "sticking-your-nose-into-things" – characteristics all found in O'Keeffe's flower paintings. Alfred Stieglitz also drew upon Whitman's ideas.

ILLUSTRATION PAGE 36:
Black Iris III, 1926
Oil on canvas, 91.4 x 75.9 cm
New York, The Metropolitan Museum of Art,
The Alfred Stieglitz Collection, 1969

she refused to see an unexpected visitor in order to be able to complete a still life before the flower wilted. O'Keeffe's emphasis upon the individual form, and her presentation of single, centrally-positioned flowers enlarged to an unnatural size, correspond to a romantically-exalted way of seeing which ascribes an anthropomorphic significance to its subject. Indeed, her approach may be aptly described in the words of the Romantic poet William Wordsworth: "To every natural form, rock, fruit or flower, / Even the loose stones that cover the high-way, / I gave a moral life, I saw them feel, / Or link'd them to some feeling [...]"

A similar approach can also be discovered amongst the American Luminists of the latter half of the 19th century, who continued the Romantic tradition of flower painting in their own portrayals of flowers, often presented at extremely close range. Thus Martin Johnson Heade's positioning of a single magnolia in the centre of the composition (p. 38), making it the object of the viewer's undivided attention, reveals the same respect for the individuality of the flower as demonstrated again and again by O'Keeffe in her still lifes. In its detailed characterization and its smooth, shiny leaves,

this magnolia by Heade celebrates the perfection and objective beauty of a flower in the same way as the heads of O'Keeffe's *Oriental Poppies* of 1928 (p. 39).

In 1924 Georgia O'Keeffe began to devote herself to a more realistic manner of representation. As she herself declared, she thereby hoped to refute the sexualist interpretations which, from the very start, had been placed upon her abstract work. In the social climate of the America of the twenties and of a New York public enamoured with the latest theories of Sigmund Freud, O'Keeffe's outsized flowers and enlarged details of plant anatomy were attributed with unfeignedly erotic implications. The artist herself dismissed such interpretations out of hand: "Well – I made you take time to look at what I saw and when you took time to really notice my flower you hung all your own associations with flowers on my flower and you write about my flower as if I think and see what you think and see of the flower – and I don't."

It is true that certain of the reproductive organs of plants bear resemblances to those of humans, and that O'Keeffe's intimate views into open calices can thus indeed call up associations of a definitely erotic nature. But it is an essential characteristic of O'Keeffe's work, and one that gives her painting its depth and strength; the final interpretation is left open. Her exposure to the photographs of Stieglitz and Strand, and her familiarity with the technique of alienating a subject by removing it from its larger context, led her to formulate the following maxim in 1922: "Nothing is less real than realism. […] It is only by selection, by elimination, by emphasis that we get at the real meaning of things."

In her search for the "real" meaning of things, O'Keeffe appears to take up the equivocalness of reality in a number of ways. In *Two Calla Lilies on Pink* p. 30), it is not just the ambiguous patterning of the pink background, echoing the organic structures of the flowers, which defies specific interpretation; the lighting within the picture and the modelling of the leaves also help complicate matters. What at first sight appears to be a naturalistic portrait reveals itself, upon closer inspection, to be something quite different. This disconcerting, alienating effect is compounded by the apparent magnification of the flowers – O'Keeffe's flowers in fact occupy the canvas in places in life size. In this respect O'Keeffe draws close to currents in Euro-

Martin Johnson Heade:
The Magnolia Flower, c. 1885–95
Oil on canvas, 39.1 x 61 cm
San Diego (CA), The Putnam Foundation,
Timken Museum of Art

A physical proximity to nature and a focus upon the microcosm of the flower are also two of the elements characterizing the still lifes which Martin Johnson Heade (1819–1904) produced in the late 1800s. Although the magnolia in the present composition is apparently dead, cut from the tree, it continues to revel in its luxuriant beauty.

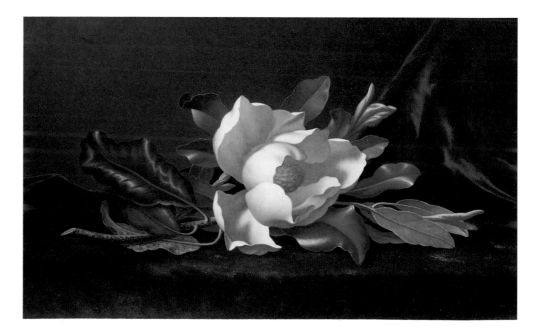

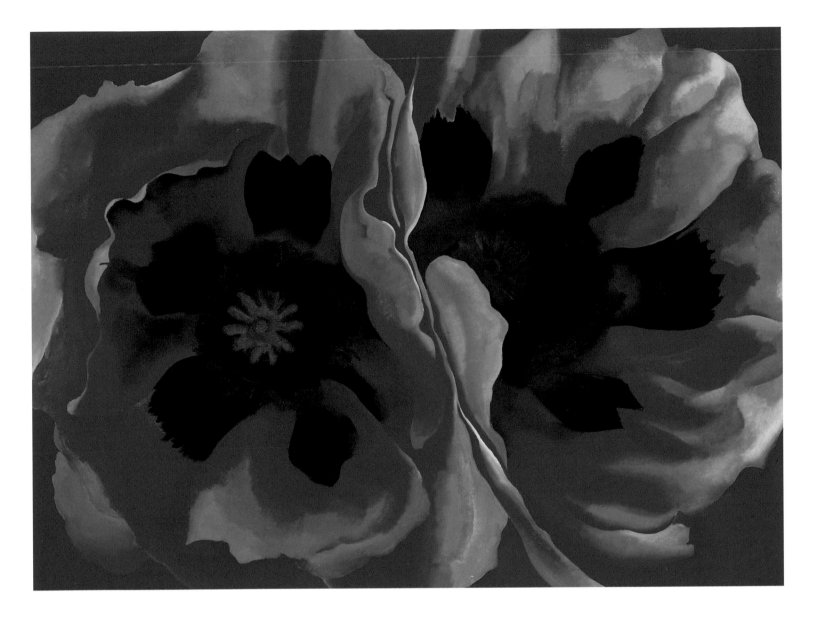

pean art in the 1920s, including the Magic Realism whose influence also extended to America. As in contemporary trends in Europe, the artist's vision is informed by the belief that, behind realism and the precise representation of objects, there lies a quite different reality. Although the natural appearance of the object may be preserved, it is never mere description. In order to render visible the quintessence of things, the external form of the motif is simplified. Each detail must be observed in depth so that the picture discloses itself to the viewer in its entirety.

A second major thematic group of works preoccuping O'Keeffe throughout the twenties are her paintings of New York City. In their simplified, geometrically-reduced forms, clear lines and smooth, polished surfaces, they establish a clear link with Precisionism, a contemporary American variety of realism. Both painters and photographers were working in the Precisionist style, which was characterized by objectivity, uniform focus and precision, and their subject matter frequently overlapped; such parallels find visible expression in O'Keeffe's painting.

As increasingly in her work, it was O'Keeffe's fascination with a particular form – in this case, the skyscraper – that led her to paint her first cityscape, *New York with Moon* of early 1925. At this stage, the high-rise buildings piercing the urban skies which provided her inspiration are rendered only schematically, in the dim light of a street lamp. That autumn O'Keeffe and

Oriental Poppies, 1928
Oil on canvas, 76.2 x 101.9cm
Minneapolis (MN), Weisman Art Museum,
University of Minnesota

"A flower is relatively small. Everyone has many associations with a flower – the idea of flowers. [. . .] So I said to myself – I'll paint what I see – what the flower is to me but I'll paint it big and they will be surprised into taking time to look at it [. . .]" GEORGIA O'KEEFFE

Stieglitz moved into the Shelton Hotel, completed a year earlier, where they rented a two-roomed suite first on the 28th and later on the 30th floor. At that time, most of the upper storeys of skyscrapers were still given over to offices, and O'Keeffe and Stieglitz were among the first to live above the roofs of Manhattan. The panoramic views from their apartment renewed the artist's interest in capturing New York on canvas. O'Keeffe's male colleagues, who viewed architectural subjects as their rightful domain, considered the idea impossible. O'Keeffe took their opposition as a challenge, and proved them wrong with her success: her first New York painting was sold on the very first day it went on show.

The skyscrapers she chose as her subjects reflected the modern style of architecture which had begun to spring up around Grand Central Station in the "roaring twenties". Although New York did not properly develop its characteristic skyline until the 1930s, the size and monumentality of such edifices as the Radiator Building (p. 51) and the Shelton Hotel (pp. 46 and 47) – whose construction O'Keeffe had followed with interest from her studio nearby – made them symbols of modernism. European artists such as Marcel Duchamp and Francis Picabia had been exhorting their American contemporaries ten years earlier to embrace New York's architecture as an expression of the modern age, but it was only now, in the 1920s, that American artists began to wake up to their surroundings.

O'Keeffe's own glorifying attitude towards modern architecture, as reflected in her canvases from 1925 onwards, may have been influenced by Claude Bragdon, an architectural theorist who also lived in the Shelton Hotel and whom she knew. In an essay on the recently completed Shelton, Bragdon wrote: "Not only is the skyscraper a symbol of the American Spirit – restless, centrifugal, perilously poised – but it is the only truly original development in the field of architecture to which we can lay unchallenged claim."

O'Keeffe's paintings of New York City and its architecture may almost be seen as a counterpoint to the rest of her œuvre. In the – over twenty – urban landscapes she executed between 1925 and 1930, she invokes a dimension which is all but absent from her other series: time. "Her" New York, i.e. the New York that we meet in her canvases, is atmospheric and visionary. In O'Keeffe's own words: "One can't paint New York as it is, but rather as it is felt."

This emotionally oriented way of seeing the city was one she shared with other artists. The American writer Truman Capote, for example, was to describe his experience of New York many years later in terms which echo the vision offered in O'Keeffe's paintings: "It is a myth, the city, the rooms and windows, the steam-spitting streets; for anyone, everyone, a different myth, an idol-head with traffic-light eyes winking a tender green, a cynical red. This island, floating in river water like a diamond iceberg, call it New York, name it whatever you like; the name hardly matters because, entering from the greater reality of elsewhere, one is only in search of a city, a place to hide, to lose or discover oneself, to make a dream wherein you prove that perhaps after all you are not an ugly duckling, but wonderful and worthy of love..."

O'Keeffe painted several versions of the Shelton Hotel from ground level. In conjunction with the portrait format, this perspective emphasizes the verticality of the building. As the architect Le Corbusier so aptly observed: "New York is a vertical city." By taking a worm's-eye view in so many of her urban landscapes, O'Keeffe paid homage to this vertical dimension. Her interest lay not in the individual buildings themselves, however; these are

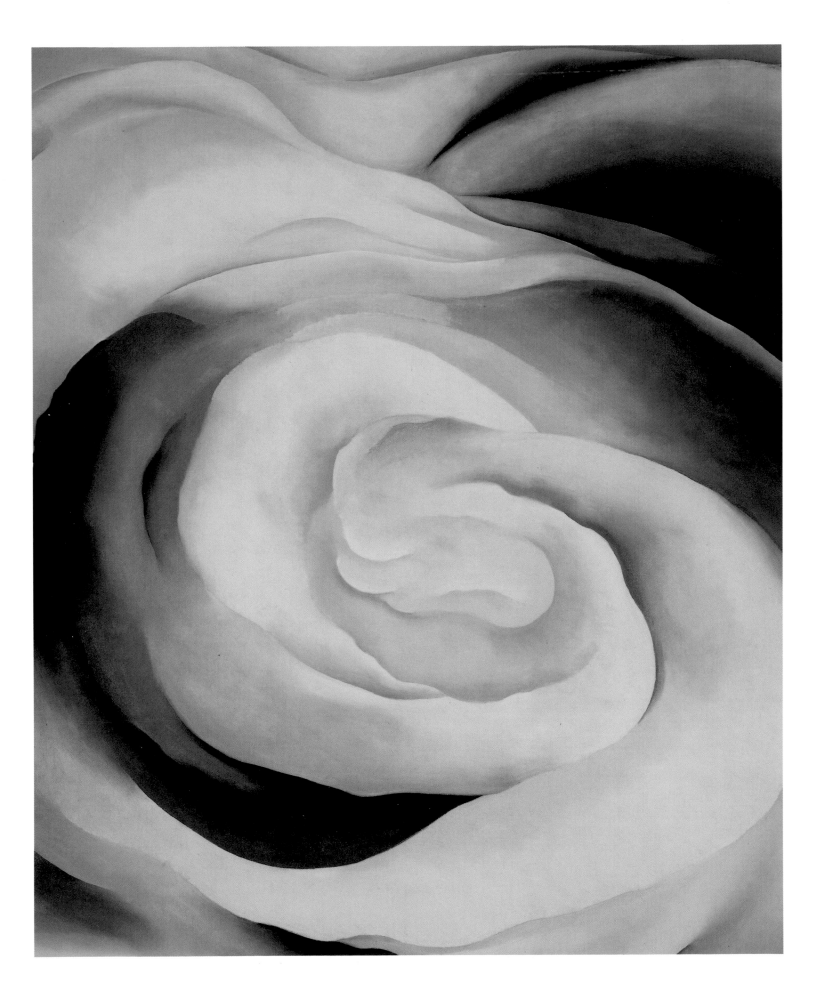

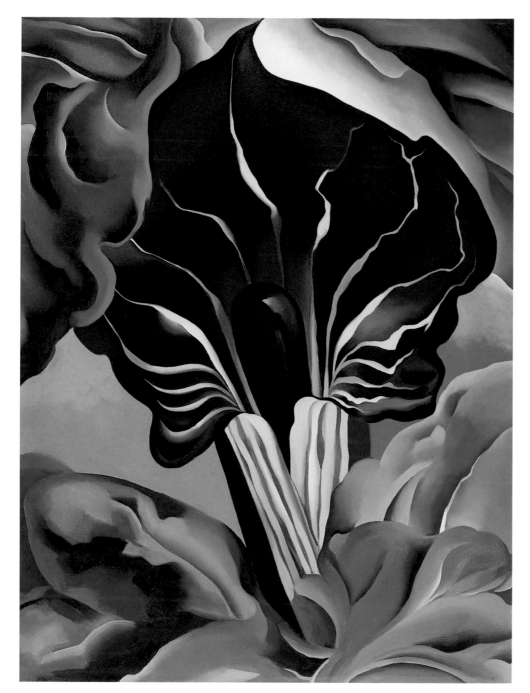

"There is no such thing as abstraction: it is ex-traction, gravitation, and minding your own busi-ness." Arthur G. Dove's philosophy of art was very close to O'Keeffe's own. Dove came to the conclusion that great art, both past and present, rested upon just a small number of fundamental principles. One of the most obvious of these, he believed, was the choice of a simple motif. This was a principle he also identified in nature, in which just a few colours and forms suffice to cre-ate a beautiful object. O'Keeffe, who greatly ad-mired Dove's work, made his ideas her own: the basic principles of natural and artistic creation are revealed in the simplicity of her motifs.

often reproduced only schematically, in outline, their windows merely sug-gested. This simplified treatment emphasizes the external form of the build-ings and brings their formal character to the fore. The almost flat treatment of their façades lends them the nature of stage scenery, and they indeed serve as the setting for something else – the changing play of light in the city sky. The few clear patches of open sky, glimpsed between the soaring sky-scrapers and receding rows of buildings, reveal an undisguised view of the horizon which is present even in the metropolis.

In seeking to express the atmospheric quality of the city at different times of day and in different weathers, O'Keeffe shared the endeavours of Stieglitz in his photography. Stieglitz, who had been taking photographs of New York since the 1890s, also sought to capture New York under particular atmo-spheric conditions – in the rain, for example, or during a snowstorm, and at different times of the day and night. In many of his photographs, such as *The City of Ambition* of 1920 (p.46), his perception of New York is very similar to that of O'Keeffe.

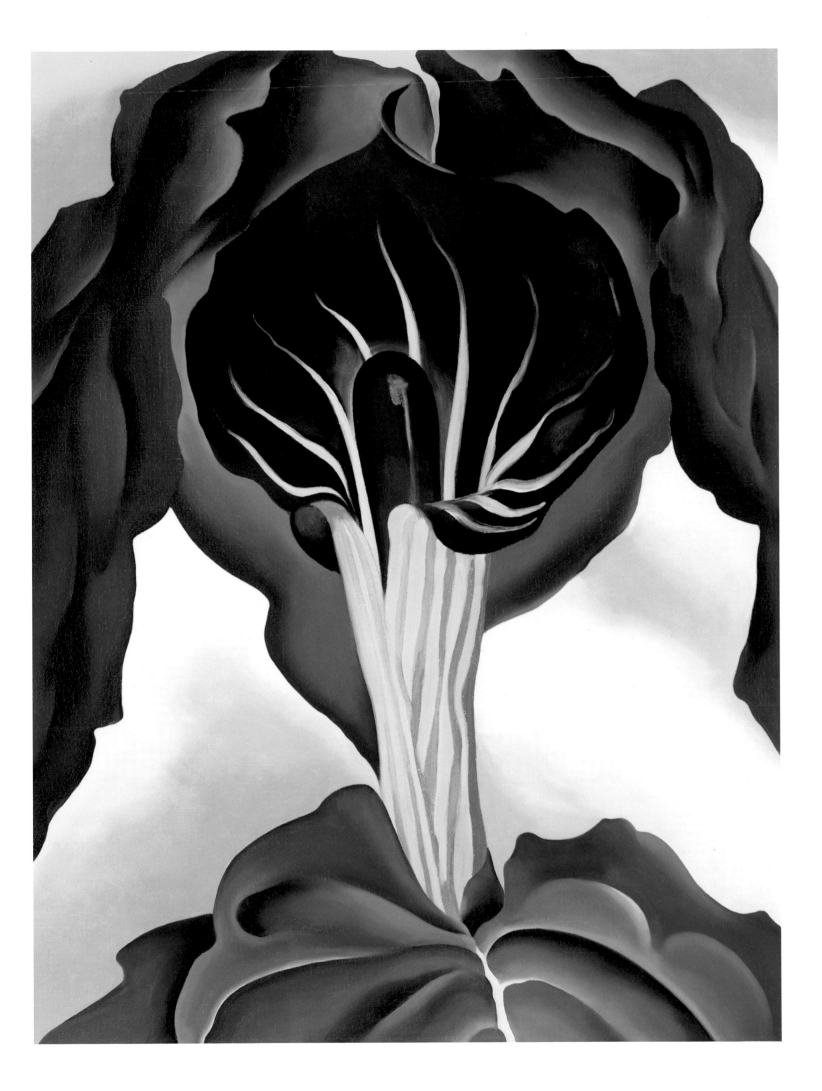

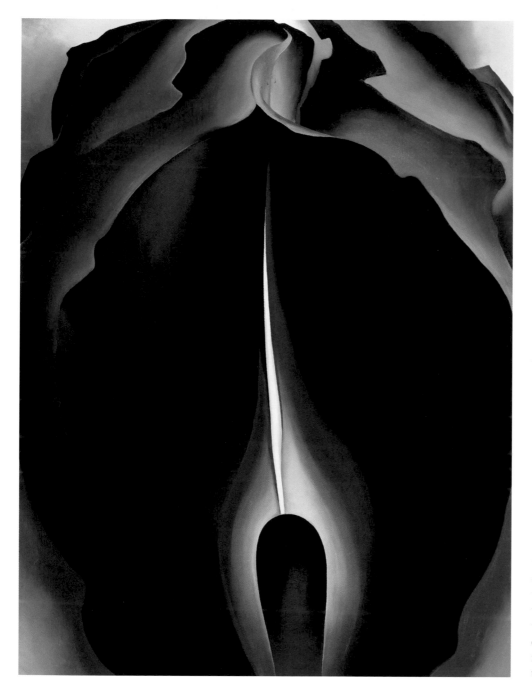

Jack-in-the-Pulpit IV, 1930
Oil on canvas, 101.6 x 76.2cm
Washington (DC), Alfred Stieglitz Collection,
Bequest of Georgia O'Keeffe
© 1994 National Gallery of Art

ILLUSTRATION PAGE 45:
Jack-in-the-Pulpit VI, 1930
Oil on canvas, 101.6 x 76.2cm
Washington (DC), Alfred Stieglitz Collection,
Bequest of Georgia O'Keeffe
© 1994 National Gallery of Art

Just how closely natural and man-made objects
resemble each other when viewed from Georgia
O'Keeffe's distinctive perspective is made clear
by the comparison between her flowers and her
skycrapers. In each case the artist positions her-
self very close to her subject, observing it from
an extreme worm's-eye view and thus raising it
to the status of a momument. The absolute size
of the object, its dimension, is concealed behind
the relative size presented within the format of
the picture, its proportion. O'Keeffe thereby re-
veals a reverence for all Creation, the same rev-
erence which, according to Walt Whitman,
makes no distinction between a leaf of grass and
the stars in the firmament.

In her adoption of such extreme perspectives from which to paint the city,
O'Keeffe in turn seems to employ a photographer's eye. At the start of the
twenties, for example, the photographer and painter Charles Sheeler (1883–
1965), who was closely connected with the artists in Stieglitz' circle al-
though never actually part of the Stieglitz stable himself, collaborated with
Paul Strand on a short film entitled "Mannahatta". The film showed the city
from unusual perspectives – from extreme bird's-eye and worm's-eye views.
Sheeler subsequently transferred these striking perspectives onto his can-
vases (p. 52). O'Keeffe must have been familiar with the short film and its
extreme angles, as can be deduced, amongst other things, from her own trip-
tych *Manhattan* of 1932. Here, three views of New York skyscrapers are sep-
arated – almost like contact proofs – by a painted black strip running thc full
height of the canvas.

The adoption of a photographic perspective is particularly apparent in *City
Night* of 1926 (p. 53). Here O'Keeffe portrays the skyscrapers with the same
perspectival distortion as would be recorded by a camera pointing straight

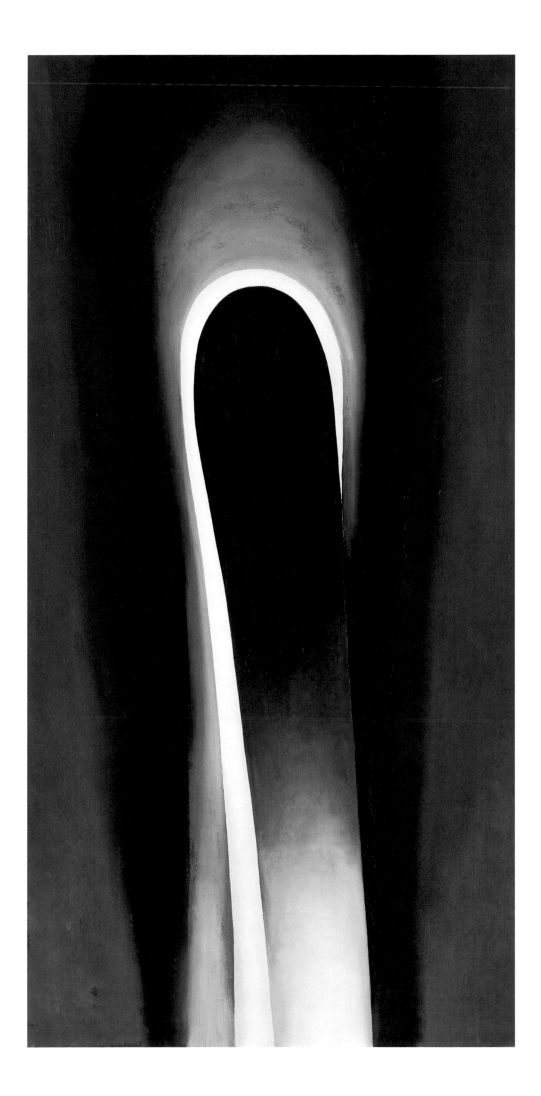

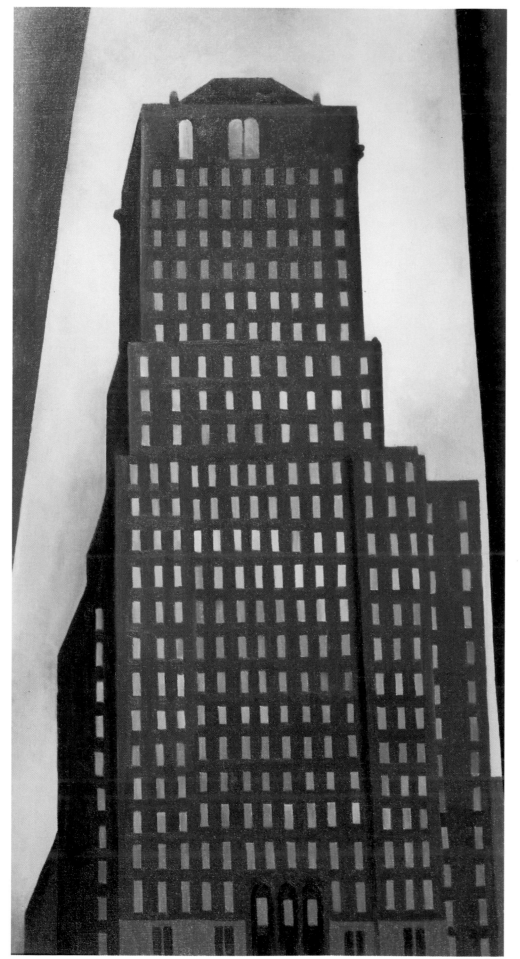

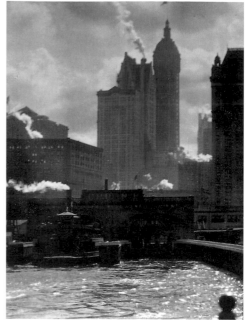

Alfred Stieglitz:
The City of Ambition, 1910
Photographic print
Philadelphia (PA), Philadelphia Museum of Art:
Alfred Stieglitz Collection

ILLUSTRATION PAGE 47:
The Shelton with Sunspots, 1926
Oil on canvas, 123.2 x 76.8 cm
Chicago (IL), The Art Institute of Chicago, Gift
of Leigh B. Block, 1985.206

Shelton Hotel, New York, No. 1, 1926
Oil on canvas, 81.3 x 43.2 cm
Minneapolis (MN), The Regis Collection

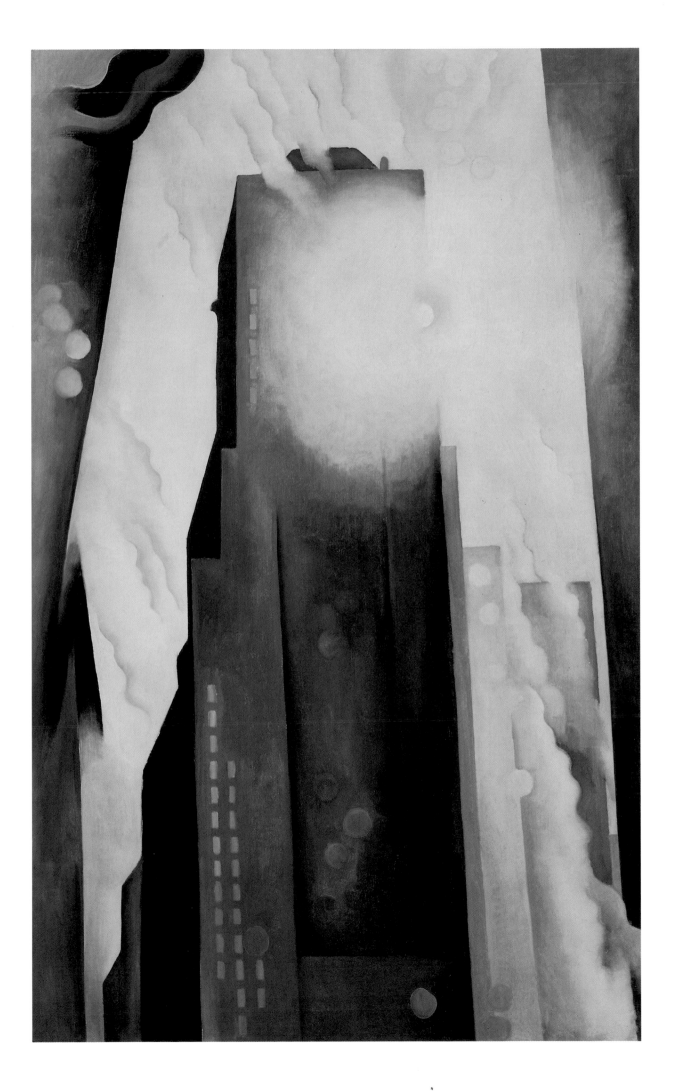

Alfred Stieglitz:
View of Brooklyn across the East River from the Shelton Hotel, 1931
Gelatin silver print
Philadelphia (PA), Philadelphia Museum of Art: Alfred Stieglitz Collection

A fascination with the big city can be traced throughout the art of the twenties. It seems that artists found the complexity and liveliness of the metropolis a more interesting and rewarding subject for their attention than the simplicity and naïvety of rural life. In typical fashion, Stieglitz captures the urban industrial scene as a landscape whose forms stretch away to the horizon. The man-made world recorded by Stieglitz and O'Keeffe from their apartment in the Shelton Hotel becomes the pendant to the natural world.

upwards at the same scene. Thus the façades of the perpendicular high-rises in their parallel rows are transformed into lozenge-shaped planes, in an effect known as converging verticals.

In her paintings of the city, O'Keeffe attaches particular significance to light. In her masterly *The Shelton with Sunspots* of 1926 (p. 47), she captures the fleeting effect of a blinding ray of sunlight as it might strike a city dweller accustomed to limited sun, for whom the unaccustomed sight of full sunshine finding its way into the narrow streets beneath the towering skyscrapers is a rare experience indeed. The picture is flooded by a diffuse light which seems to float downwards in clouds of haze. The impression of dazzling light is reinforced not only by the brightness irradiating the hotel façade in the upper half of the picture, but – more significantly – by the "sunspots" dotted at irregular intervals across the picture, their partially transparent nature lending them a distinctly atmospheric quality. Through their irregular positioning and their semi-transparency, these sunspots successfully create much the same hazily shimmering effect produced by a camera taking a photograph into the sun, during which light reflections arise on the surface of the lens and subsequently appear on the film. The extensive halo surrounding the bright core of the sun is also an effect that O'Keeffe may well have noted in photography.

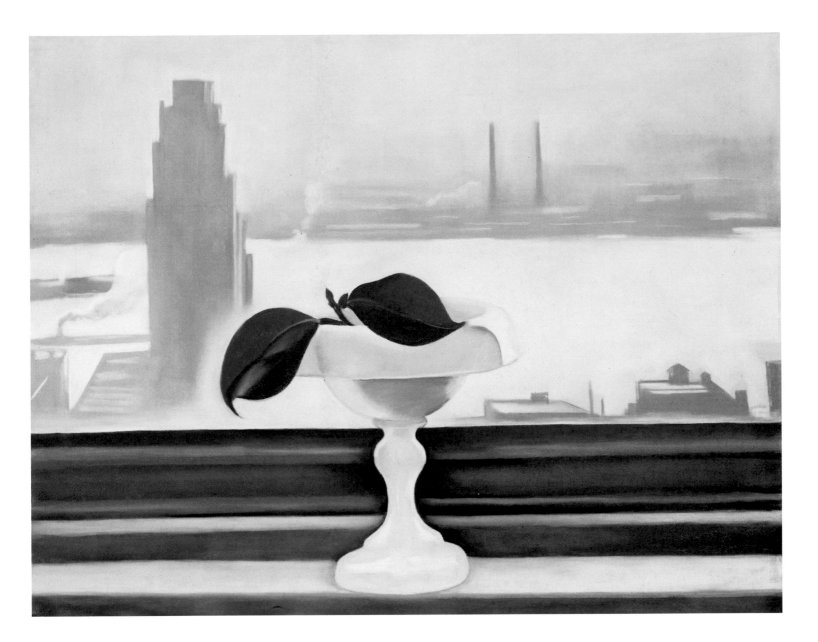

O'Keeffe's paintings of New York thus make subtle reference to the light conditions in a big city, where natural light rarely falls directly on a building, but is more often cast as a reflection. The visual impression of reflecting light also appears to have inspired her in *Shelton Hotel, New York, No. 1* of 1926 (p. 46): here, the squares of the windows are depicted in multiple shades of grey and white, evoking the effect of an irregular distribution of light and thus of panes of glass casting different reflections.

For O'Keeffe, every hour of the day and night held its own significance. The atmospherically subjective quality of the artist's cityscapes reached its culmination point in her paintings of New York by night, which are dominated by the artificial lights of the big city: brightly lit windows, fluorescent spotlights playing on soaring spires, dazzling headlights, advertisements in illuminated letters, traffic lights and neon signs – Manhattan as a city of light. The starting-point for a number of these compositions, amongst them *New York, Night* of 1929 (p. 50), was the view from the windows of O'Keeffe's high-rise apartment, from where she could watch the seething lights of the evening traffic along Lexington Avenue, with the Berkeley Hotel in the foreground. As in *New York, Night*, she frequently offers an only summary view of the city from above. She captures a series of fleeting events which are taking place side by side but which the human eye, at this elevated height, can

Pink Dish and Green Leaves, 1928
Pastel on paper, 55.9 x 71.1 cm
© Juan Hamilton

Another view from the same window: Georgia O'Keeffe underlines the drastic contrast between the natural and the man-made world. Two leaves lie forlornly in a dish, the last relics of organic form within an otherwise rigorously geometric architecture. In an urban landscape in which trees and plants have vanished, everyday objects must preserve the memory of nature.

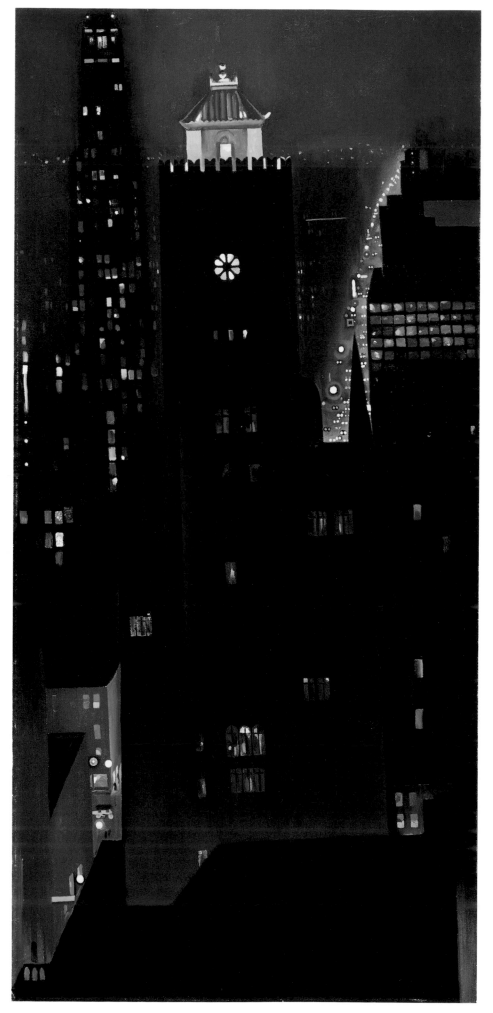

New York, Night, 1929
Oil on canvas, 101.6 x 48.3cm
Lincoln (NE), Collection of the Sheldon Memorial Art Gallery, University of Nebraska Art Galleries

ILLUSTRATION PAGE 51:
Radiator Building, Night, New York, 1927
Oil on canvas, 121.9 x 76.2cm
Carl van Vechten Gallery of Fine Arts, Fisk University

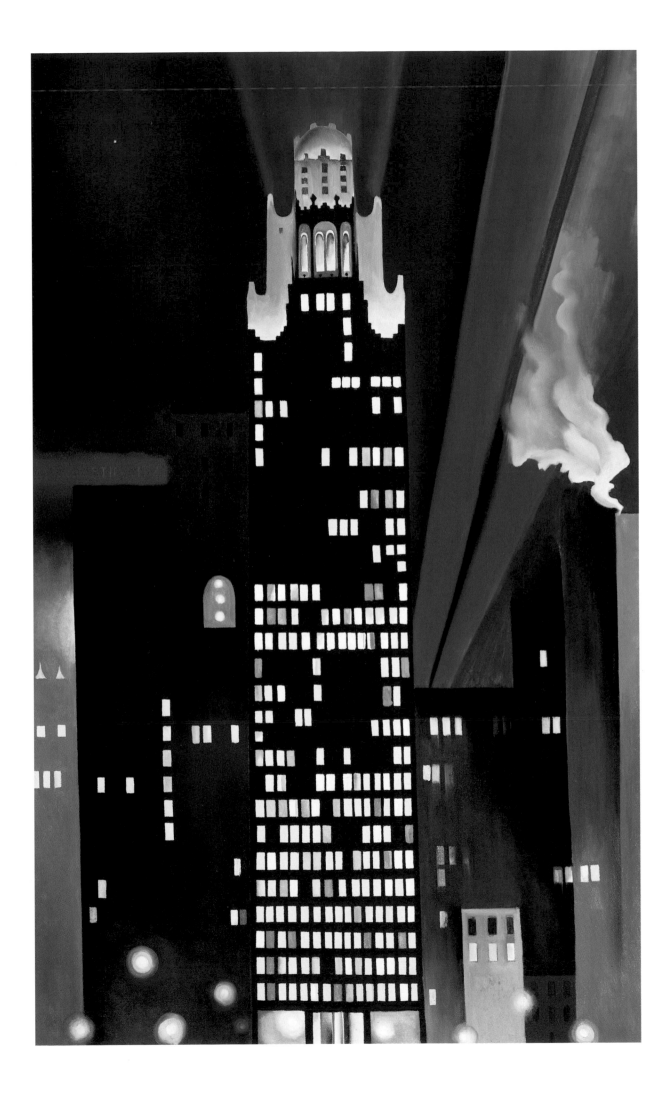

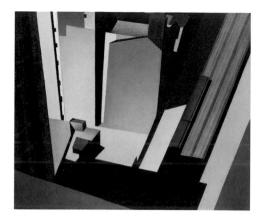

Charles Sheeler:
Church Street El, 1920
Oil on canvas, 40.6 x 48.5 cm
Cleveland (OH), © The Cleveland Museum of
Art, Mr and Mrs William H. Marlatt Fund

Charles Sheeler was associated with the circle of
artists around Alfred Stieglitz. In this painting,
which he based on a still from his short film
"Mannahatta", he embraces a more radical mod-
ernity than Georgia O'Keeffe. Portrayed from
the perspective of a passing aeroplane, the face-
less skycrapers fuse into a staccato of uniformity.

only register somewhat out of focus and one after the other. O'Keeffe may
have been inspired to paint from this bird's-eye perspective by the optical
angles adopted in photographs, in particular those employing a telephoto
lens, which would have given her a detailed idea of the arrangement of the
city, its patterns and surfaces.

The photographers Stieglitz, Strand and Sheeler shared the view of the philo-
sopher Henri Bergson that the human spirit cannot adequately grasp the
flow of time; in order to arrive at a true understanding of things, time would
need to be interrupted. The three felt that photography had a valuable role to
play here, since it offered a unique opportunity to seize a moment in time
and fix it on film. They believed, moreover, that a photograph could not
only fix one such moment, but could also capture and lay bare the essence of
an object. Hence Stieglitz considered weather and atmosphere the only con-
ditions which enabled a photographer to take a "true" photograph.

Photographic perspectives and pictorial components such as light reflections
thus became the creative design elements through which O'Keeffe gave ex-
pression to her romantic feeling for the metropolis. In choosing to concen-
trate in her paintings upon the momentary and changing aspects of the phe-
nomenal world, O'Keeffe may have been inspired by the philosophy of the
photographers around her, for whom capturing the fleeting impression of a
moment on camera simultaneously contained the possibility of discovering
the essence of the chosen motif. Georgia O'Keeffe's unique achievement in
her paintings was to render visible the intangible charisma and fascination of
New York City.

ILLUSTRATION PAGE 53:
City Night, 1926
Oil on canvas, 121.9 x 76.2 cm
Minneapolis (MN), The Minneapolis Institute of
Arts, Gift of the Regis Corporation. Mr and
Mrs W. John Driscoll

Georgia O'Keeffe was familiar with the perspec-
tival distortions produced by the camera angles
employed by Charles Sheeler and Paul Strand in
their photographs of architecture. The sky-
scrapers in her own paintings are subject to the
same foreshortening as would be seen in a photo-
graph taken by a camera lens pointed upwards.
In painting, however, the technical problem
becomes an artistic device. Once again, the build-
ings become monuments, symbols of the pro-
gress of civilization – and its dangers.

52

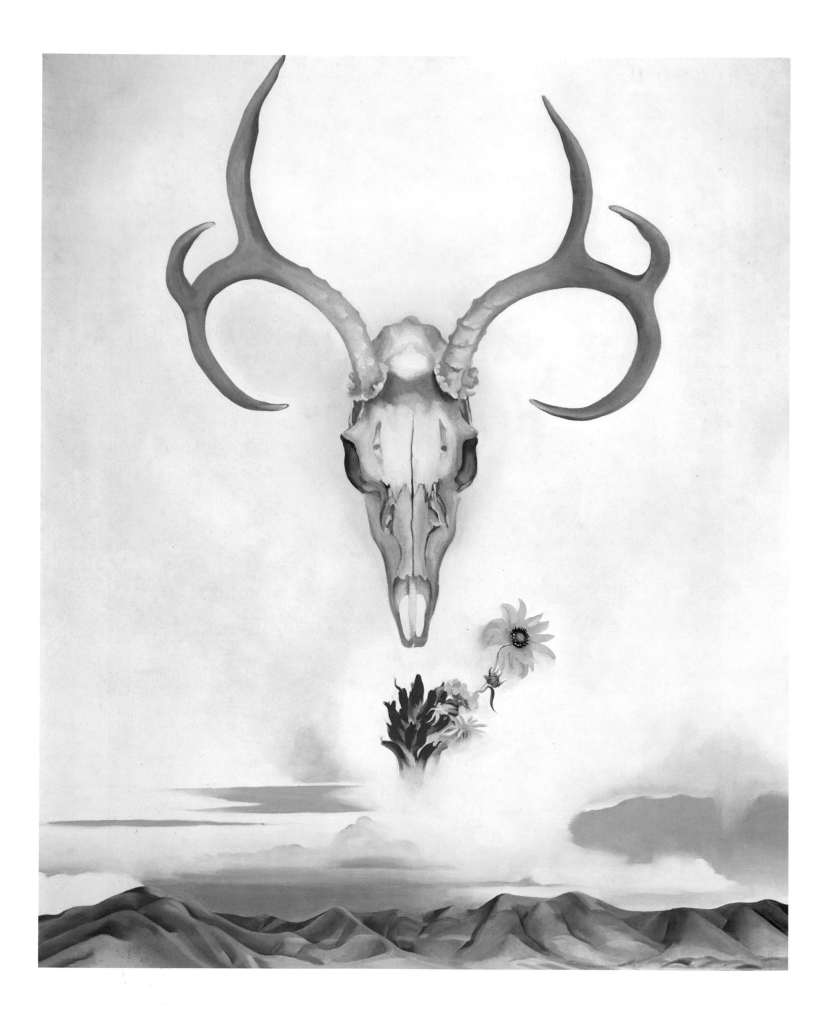

Desert visions

Two serious breast operations in 1927, compounded by tensions within her private life and Stieglitz' interest in another woman, led Georgia O'Keeffe, towards the end of the twenties, to concentrate more strongly upon her own development and self-assertion as an artist. Following her own path simultaneously meant freeing herself more and more from Stieglitz' dominance. The struggle for self-realization at Stieglitz' side was a hard one, as O'Keeffe acknowledged many years later in the following words: "[…] His power to destroy was as destructive as his power to build – the extremes went together. I have experienced both and survived, but I think I only crossed him when I had to – to survive."

In the summer of 1929 O'Keeffe accepted an invitation from Mabel Dodge Luhan, a wealthy writer and champion of the arts who liked to surround herself with artists, to visit her in Taos. She was accompanied on the trip by Rebecca Strand, the wife of photographer Paul Strand. O'Keeffe had first seen the deep canyons and forested mountains of the New Mexico tableland in 1917, en route to Colorado, and had been instantly enthralled. "I loved it immediately," she later recalled. "From then on I was always on my way back." The idyllic views of the low mountains and hills around Lake George, and the permanent, saturated green of the landscape, were unable to provide O'Keeffe with truly fulfilling material for her painting in the long term. She needed the wide open spaces in which she had grown up as a child and which she had rediscovered as a young woman in the plains of northern Texas. Writers and painters had been coming to New Mexico since the mid-19th century, drawn by its dramatic, high-lying desert landscape and its intense light. The spell which the Southwest cast upon artists is perhaps best expressed in the lyrical words of D.H. Lawrence, who himself lived in New Mexico for a while: "[…] The moment I saw the brilliant, proud morning shine high up over the deserts of Santa Fe, something stood still in my soul, and I started to attend. There was a certain magnificence in the high-up day, a certain eagle-like royalty […]. In the magnificent fierce morning of New Mexico one sprang awake, a new part of the soul woke up suddenly, and the old world gave way to a new."

O'Keeffe, like other painters before her, appears to have found it difficult at first to do justice on canvas to the mysterious beauty of this new landscape. Marsden Hartley, who had been another of Mabel Dodge Luhan's guests a few years earlier, described the challenges which New Mexico presented the artist in a letter to Stieglitz: "This country is very beautiful and also difficult […] it is not a country of light on things. It is a country of things in light, therefore it is a country of form, with a new presentation of light as problem."

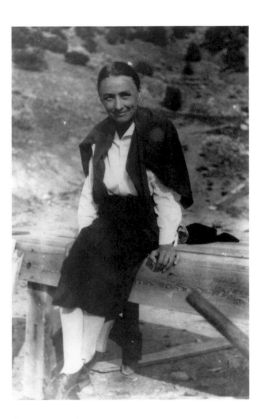

Anonymous:
Georgia O'Keeffe at the Pink House in Taos, New Mexico, 1929
Photograph
Santa Fe (NM), Courtesy Museum of New Mexico, Neg. No.9763

ILLUSTRATION PAGE 54:
Summer Days, 1936
Oil on canvas, 92.1 x 76.7 cm
New York, Whitney Museum of American Art.
Promised gift of Calvin Klein

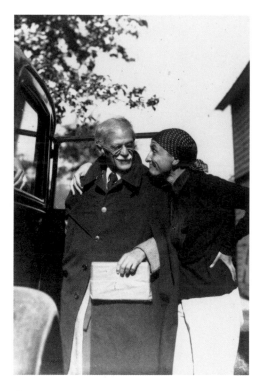

Anonymous:
Alfred Stieglitz and Georgia O'Keeffe, 1932
Photograph
New Haven (CT), Courtesy of Beinecke Rare
Book and Manuscript Library, Yale University
Library

Utagawa Hiroshige:
Plum Orchard in Kameido, 1857
Colour woodcut, 36.3 x 24.6cm
Amsterdam, Rijksmuseum Vincent van Gogh,
Vincent van Gogh Foundation

Exploring numerous new motifs reflecting the culture and traditions of New Mexico, O'Keeffe slowly felt her way into the landscape. She was particularly drawn to the Spanish mission church of Ranchos de Taos, dating from the 18th century, with its natural adobe walls and clear, rounded lines. She painted several versions of the church, seen from different angles, in sun and in cloud.

Another recurrent theme in these paintings of 1929 are the black crosses of the Penitentes, a religious sect known for their dogmatism. These monumental crosses, symbols of Spanish Catholicism, are scattered throughout the New Mexico desert. "For me, painting the crosses was a way of painting the country," O'Keeffe later wrote.

The Lawrence Tree (p.57), also dating from this first summer in New Mexico, offers another impression of the vegetation and landscape. This dramatic portrait of a tall pine was painted at Kiowa Ranch, where D.H. Lawrence had stayed some years earlier and where O'Keeffe also spent part of her vacation. Inspired by the sight of a pine tree which towered above her as she lay on a bench, she painted the star-studded night sky seen through the branches of the tree. The formal composition reveals an awareness of the two-dimensionality of painting as found in Japanese art and propagated by Dow: the trunk, the winding branches and the foliage are simplified here into a planar structure. The unusual, oblique perspective from below, irritating to the eye of the viewer, creates the impression that the tree is toppling over. The only way to view the composition "correctly" would be to adopt the same prone position as the artist.

O'Keeffe here presents a pictorial equivalent of the "optically true" picture that would be taken by a camera angled at an extreme slant. As in her earlier skyscrapers, photography may thus here, too, have inspired O'Keeffe's choice of perspective: a pine photographed from underneath would have the same two-dimensionality as *The Lawrence Tree*. At the same time, the oblique perspective emphasizes the size and monumentality of the tree. The diagonal of the trunk, running from the bottom right-hand corner towards the top left-hand corner, leads the eye upwards to the stars. Furthermore, O'Keeffe's rigorous simplification of the pictorial elements allows nothing to distract the viewer's attention, creating space for a meditative dialogue between the viewer and the object portrayed.

From now on O'Keeffe would regularly spend a part of the year in New Mexico. Her enduring need for solitude and quiet led her to distance herself from the colony of artists that had flourished around Taos since the end of the 19th century. As from 1931, she started spending her summers in the Rio Grande valley west of Taos, where she rented a cottage in the small village of Alcalde. She was particularly fascinated by the forms of the red sand hills with the dark mesas beyond, which never seemed to get any nearer however far one walked. With its vast wealth of colours, this barren desert landscape offered her everything that she needed for her painting: "All the earth colors of the painter's palette are out there in the many miles of badlands. The light Naples yellow through the ochres – orange and red and purple earth – even the soft earth greens."

Pink and red sand hills with rounded contours are a characteristic feature of her painting over the next few years (cf. p.68). O'Keeffe expressed her special affection for these typical features of the New Mexico desert in an exhibition catalogue in 1939: "A red hill doesn't touch everyone's heart as it touches mine and I suppose there is no reason why it should. The red hill is a piece of the badlands where even the grass is gone. Badlands roll away outside my door – hill after hill – red hills of apparently the same sort of earth

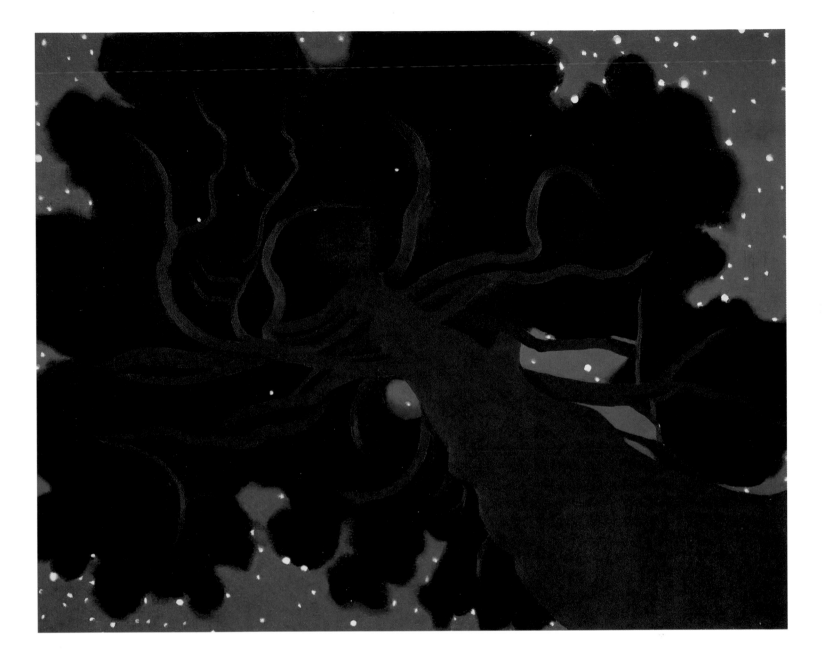

that you mix with oil to make paint. [...] You have no associations with those hills – our waste land – I think our most beautiful country. You must not have seen it, so you want me always to paint flowers..."

It was after her second or third trip to New Mexico that O'Keeffe returned to the East Coast with an assortment of bones and skulls of cattle and wild animals that she had found in the desert. As a natural component of the desert landscape, these bones held the same significance for her as shells, rocks and flowers: "I have picked flowers where I found them – have picked up sea shells and rocks and pieces of wood where there were sea shells and rocks and pieces of wood that I liked... When I found the beautiful white bones on the desert I picked them up and took them home too... I have used these things to say what is to me the wideness and wonder of the world as I live in it."

O'Keeffe's – to many people disconcerting – attachment to her desert "trophies" is documented as part of Alfred Stieglitz' comprehensive *Georgia O'Keeffe: A Portrait* (p. 58). The bones and skulls which were to resurface regularly as one of the artist's major motifs over the next few years inevitably prompted the critics to make connections with death and resurrection. In O'Keeffe's eyes, however, the sun-bleached bones are intensely alive:

The Lawrence Tree, 1929
Oil on canvas, 78.9 x 99.5 cm
Hartford (CT), Wadsworth Atheneum. The Ella Gallup Sumner and Mary Catlin Sumner Collection

ILLUSTRATION PAGE 58:
Alfred Stieglitz:
Georgia O'Keeffe: A Portrait – with Cow Skull, 1931
Gelatin silver print
Washington (DC), Alfred Stieglitz Collection, © 1994 National Gallery of Art

ILLUSTRATION PAGE 59:
Cow's Skull with Calico Roses, 1932
Oil on canvas, 91.2 x 61 cm
Chicago (IL), The Art Institute of Chicago, Gift of Georgia O'Keeffe, 1947.712

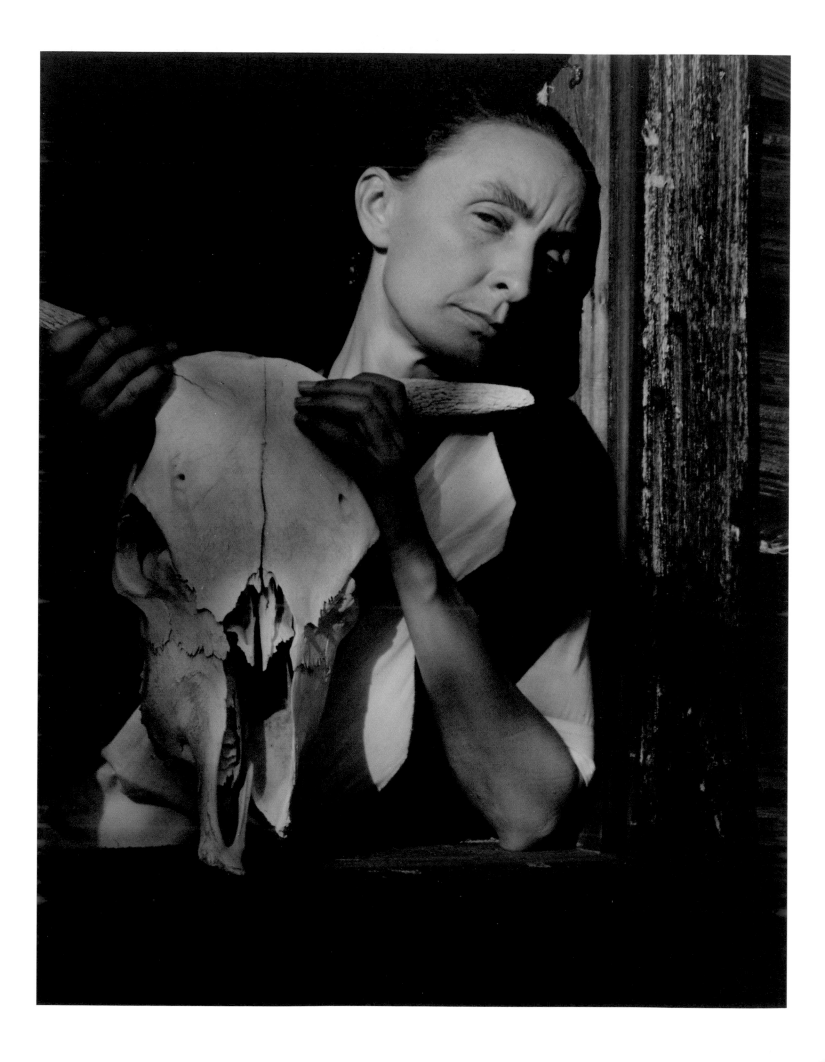

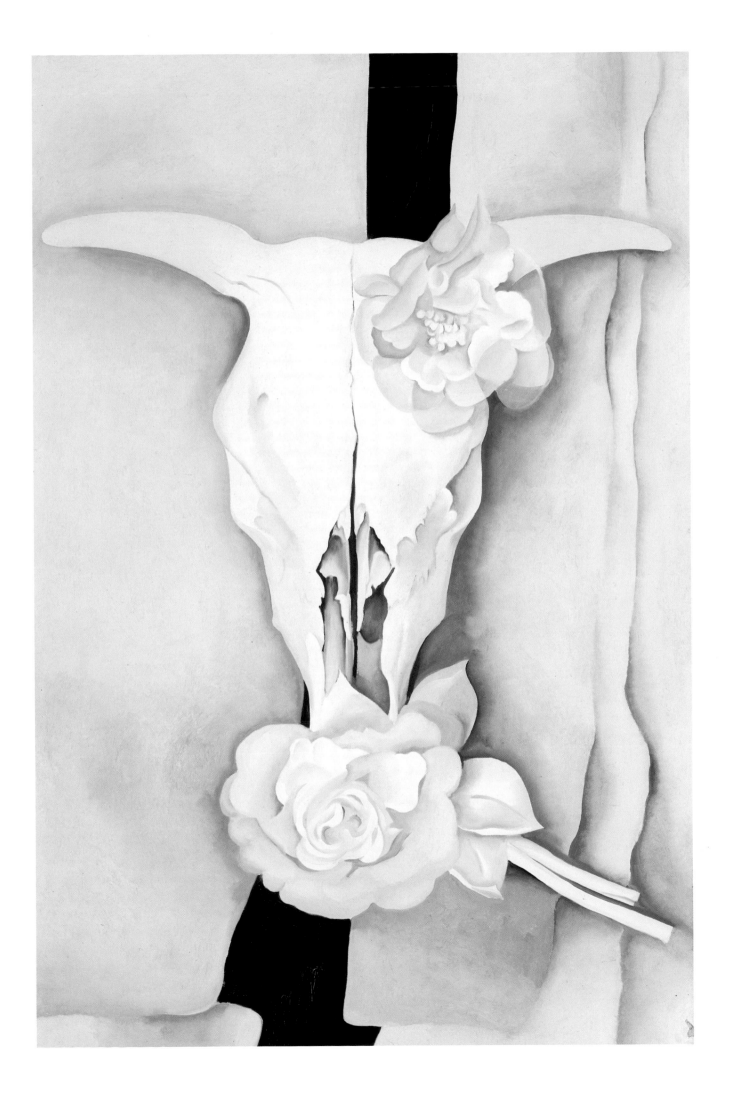

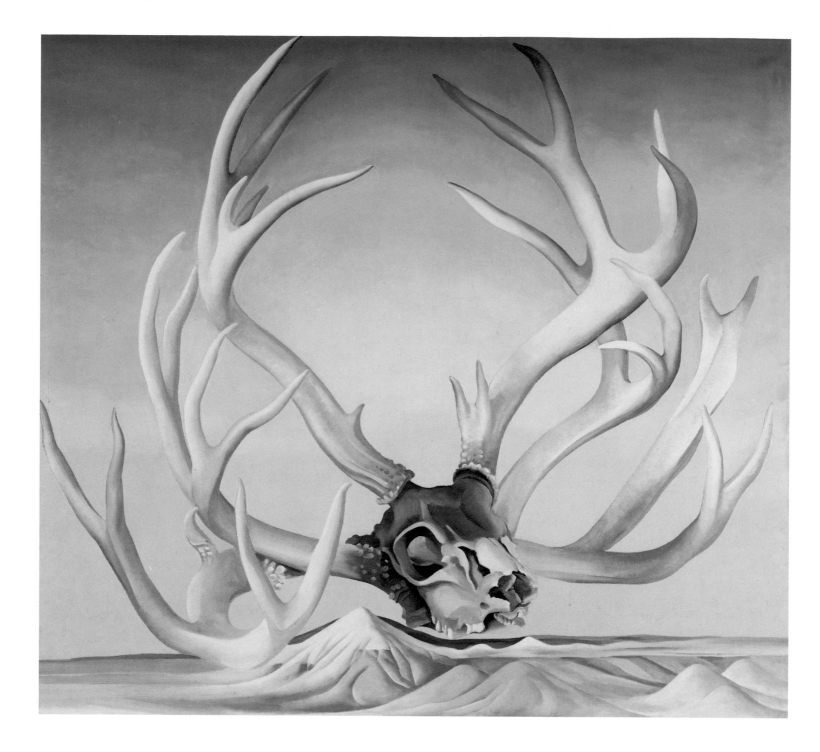

From the Faraway Nearby, 1937
Oil on canvas, 91.4 x 101.9cm
New York, The Metropolitan Museum of Art,
Alfred Stieglitz Collection, 1959

"The bones seem to cut sharply to the center of something that is keenly alive... even tho' it is vast and empty and untouchable – and knows no kindness with all its beauty."

O'Keeffe's unusual juxtaposition of skulls with artificial flowers, which are used in funerals in New Mexico by the Spanish section of the population, lends paintings such as *Cow's Skull with Calico Roses* (p.59) a surreal, mystical aura. Although seeming to echo Lautréamont's definition of Surrealism as "the encounter of an umbrella and a sewing-machine on a dissection table", this unexpected combination of a cattle skull with two artificial flowers can nevertheless be read as a statement of reality itself. The photographs by Stieglitz portraying O'Keeffe's hands resting on a cow's skull reveal this same surreal aspect of reality. In O'Keeffe's canvases, decorative interest in the subject is combined with a sense of the amusing bizarreness of surprising opposites. Many years later, the artist commented: "Often, a picture just gets into my head without my having the least idea how it got there.

But I'm much more down-to-earth than people give me credit for. At times, I'm ridiculously realistic."

Although the objects in these pictures are analysed down to the last detail in terms of their structure and texture (the skulls are among the most realistically executed objects in O'Keeffe's entire œuvre), they are presented – in a similar fashion to earlier works – against an enigmatic background. In *Cow's Skull with Calico Roses*, for example, is this background a pair of curtains, concealing an unsuspected second reality? Or perhaps some almost abstract material whose colouring and organic structuring evoke associations with desert sand?

Georgia's life in the thirties was marked by growing success and increasing recognition. The Brooklyn Museum in New York had already staged the first retrospective of her work in 1927, and her important contribution to her field was subsequently honoured in numerous ways. In addition to the purchase of one of her paintings by the Metropolitan Museum of Art, she was awarded an honorary doctorate and was voted one of the twelve outstanding women of the past 50 years. Alongside other public commissions, in 1932 O'Keeffe accepted an invitation to paint a mural for the new Radio City Music building. Disregarding opposition from Stieglitz, who rejected all commercialization of art, O'Keeffe started work on the design. Technical problems, however, forced her to abandon the project again just a short while later. Soon afterwards, O'Keeffe had a nervous breakdown: like the serious bout of psychoneurosis which she suffered the following year, it was the direct result of the continuing tensions between herself and Stieglitz. Georgia O'Keeffe stopped painting for a full year, and only returned to New Mexico in 1934.

In the summer of 1934, through the direction of a friend, she discovered the region most closely allied to her inner visual landscape. Lying further north

Hills – Lavender, Ghost Ranch, New Mexico II, 1935
Oil on canvas, 20.3 x 33.7 cm
St. Louis (MO), Mr and Mrs George K. Conant III

than Alcalde, it encompassed breathtaking views of the raw cliffs and rain-eroded hills of the Chama river valley. From now on she rented her summer accommodation at Ghost Ranch, an isolated dude ranch. In 1940 she bought her own house, Rancho de los Burros, just a few miles from Ghost Ranch. Equipped with only the basic essentials, and with animal skulls on the outside walls of the open patio and rocks lining the tables and shelves, the house, with its unique panorama of red cliffs, fulfilled all her hopes and desires. Famous artists, photographers, collectors and actors came to visit her in her new home.

For Stieglitz, who had been forced to give up photography in 1937 owing to poor health, and who suffered his second heart attack one year later, these long periods of separation were a torment. Daily letters reflected the couple's emotional and spiritual ties: "You sound a bit lonely up there on the hill," O'Keeffe wrote to Stieglitz in 1937. "It makes me wish that I could be beside you for a little while – I suppose the part of me that is anything to you is there – even if I am here."

In another thematic variant of her work in the thirties, isolated animal skulls are combined with elements of the New Mexico landscape into magnificent desert views. *Summer Days* of 1936 (p.54) is one of the most impressive compositions within this group. The outsized skull of a deer, its antlers extending to the upper edge of the picture, floats high over a mountainous desert landscape. The skull is presented frontally and draws the viewer's eye directly to itself. Wild flowers rise beneath it from a haze of glittering desert light. Beyond the mountains a storm is gathering, although the sky in the

Ansel Adams:
Georgia O'Keeffe in her Car, Ghost Ranch, New Mexico, 1937
Photograph
Carmel (CA), Photograph by Ansel Adams

This photograph by Ansel Adams, taken in 1937 during his visit to Ghost Ranch, shows O'Keeffe in her A-model Ford working on a version of *Gerald's Tree*. Adams had met Alfred Stieglitz in 1933 and went on to photograph both Stieglitz and O'Keeffe on many occasions.

ILLUSTRATION PAGE 62:
Gerald's Tree I, 1937
Oil on canvas, 101.6 x 76.2 cm
Abiquiu (NM), The Georgia O'Keeffe Foundation

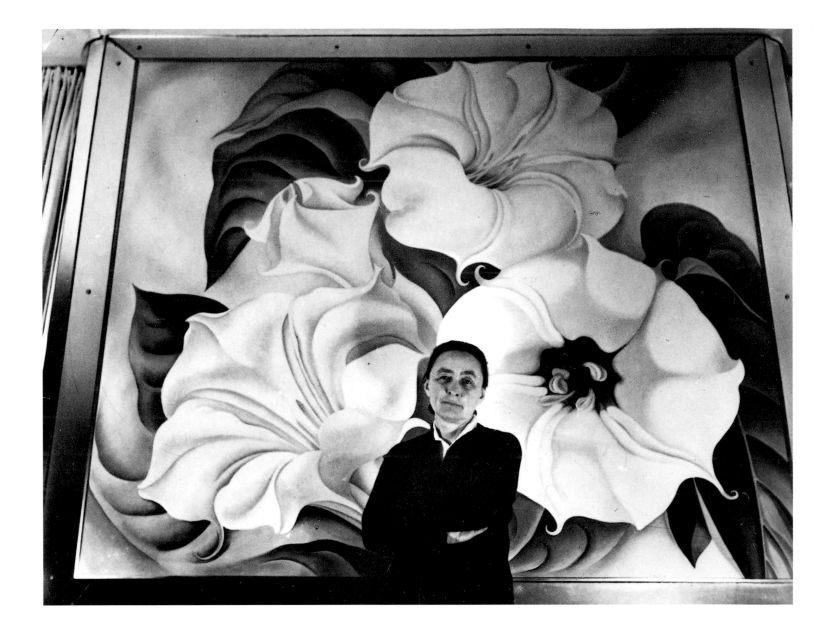

Kurt Severin:
Georgia O'Keeffe in front of the Picture which she Painted for Elizabeth Arden's Salon, 1937
Photograph
New York, LIFE MAGAZINE, © 1985 Time Warner

ILLUSTRATION PAGE 65:
Two Jimson Weeds, 1938
Oil on canvas, 91.4 x 76.2 cm
Santa Fe (NM), Private Collection, Courtesy of Gerald Peters Gallery

foreground is that of a fine summer's day. It is as if the artist wants to illustrate the neighbouring but different climatic zones which make up one of the peculiarities of New Mexico. Each element of the composition stands apart from the rest; each has its own perspective and must be registered as a separate entity by the viewer. So thoroughly is each detail explored that every component could in turn serve as the starting-point for a new painting. The artist is thereby interested in the objective beauty of her subjects, not in the process of their translation into paint. Although realistically portrayed, the objects hover between space and time. In its meditative contemplation of individual objects, *Summer Days* lies closer to still life than to landscape painting.

In *From the Faraway Nearby* (p.60), painted during the summer of 1937, O'Keeffe heightens yet further the divergences between the objects portrayed. By overlying a panorama of desert hills with an enormous stag's skull, whose antlers fill the entire surface of the picture and thereby extinguish the middle ground, the composition is lent a surreal character which borders on the fantastic. The inspiration for *From the Faraway Nearby* probably arose during a trip to Colorado which O'Keeffe undertook in 1937 with the photographer Ansel Adams, a friend she had first met in 1929. The canvas echoes some of Adams' own reactions to the desert, which he de-

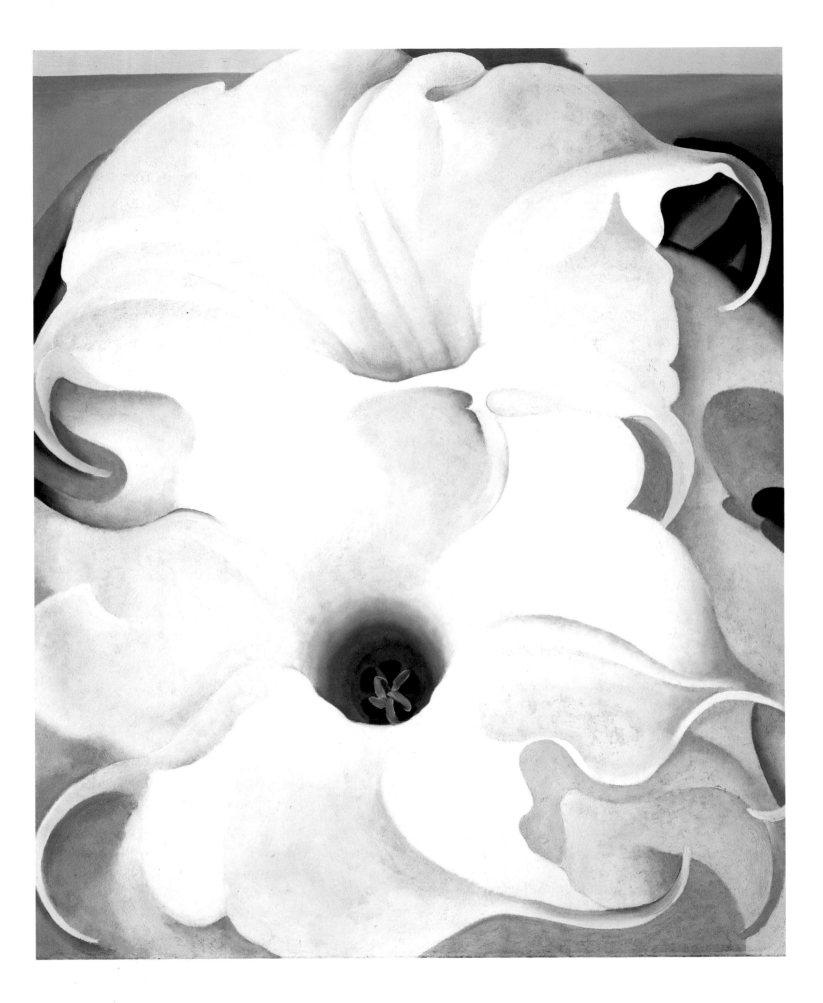

Dead Tree with Pink Hill, 1945
Oil on canvas, 77.2 x 102.2 cm
Cleveland (OH), © The Cleveland Museum of
Art, Bequest of Georgia O'Keeffe

scribed in photographic language in a letter to Stieglitz: "The skies and land are so enormous, and the detail so precise and exquisite, that wherever you are, you are isolated in a glowing world between the macro and the micro – where everything is sideways under you, and over you, and the clocks stopped long ago."

O'Keeffe's pictures capture, in an astonishing fashion, the romantic essence of the New Mexico desert, with its elementary vastness and microcosmic details. The juxtaposition of near and far is a "photographic" feature which had already appeared in such works as *Pink Dish and Green Leaves* of 1928 (p. 49). In these impressive paintings, O'Keeffe appears to draw upon the optical techniques of photography, which enable a close-up view to be combined with a long-distance shot, in order to find a valid form through which to express the "wideness and wonder of the world" in which she lived.

Like no artist before her, she captured on her canvases the region from Española to Abiquiu whose every detail she knew so well, and which is today still known as "O'Keeffe country". Setting off in her black Ford, which was roomy enough to serve as her "studio" and which protected her from the heat of the summer sun as well as from sudden downpours, the artist explored the more remote areas of New Mexico. One such was *Black Place 1* of 1944 (p. 69), whose grey hills fringed by white sand lay some 150

Cliffs Beyond Abiquiu, Dry Waterfall, 1943
Oil on canvas, 76.2 x 40.6cm
Cleveland (OH), © The Cleveland Museum of
Art

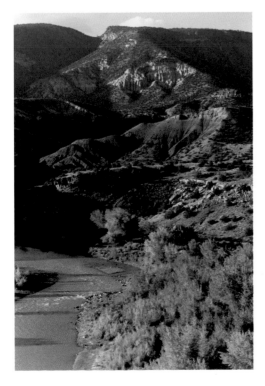

miles from Ghost Ranch. Like her flowers, hills frequently dominate the entire canvas. Zoomed into the foreground, isolated from their surroundings, and without a defining horizon, each of these "extracts" from nature challenges the viewer to complete the larger whole. In this way, O'Keeffe succeeds in capturing the majesty and grandeur of the New Mexico landscape within a single picture. The sensual quality of the rounded hills is rendered in close, even, almost invisible brush-strokes. O'Keeffe thereby makes subtle reference to the distinctive appearance of the countryside under the white desert light, which casts the shapes of the hills into crystalline focus, revealing their individual contours and surfaces and seemingly placing them almost within arm's reach. She portrays the hollows and furrows of the geological forms in a manner which recalls the folds and contours of the human body.

Throughout her painting career, O'Keeffe regularly returned to the basic forms and patterns she had discovered earlier. Wave patterns and zig-zag lines weave their way through her work in countless variations, alongside the symbolic shapes of the spiral and the circle, fused into ever new and harmonious combinations. Each picture thereby seems to take up and unite the

Small Purple Hills, 1934
Oil on cardboard, 40.6 x 50.2 cm
© June O'Keeffe Sebring

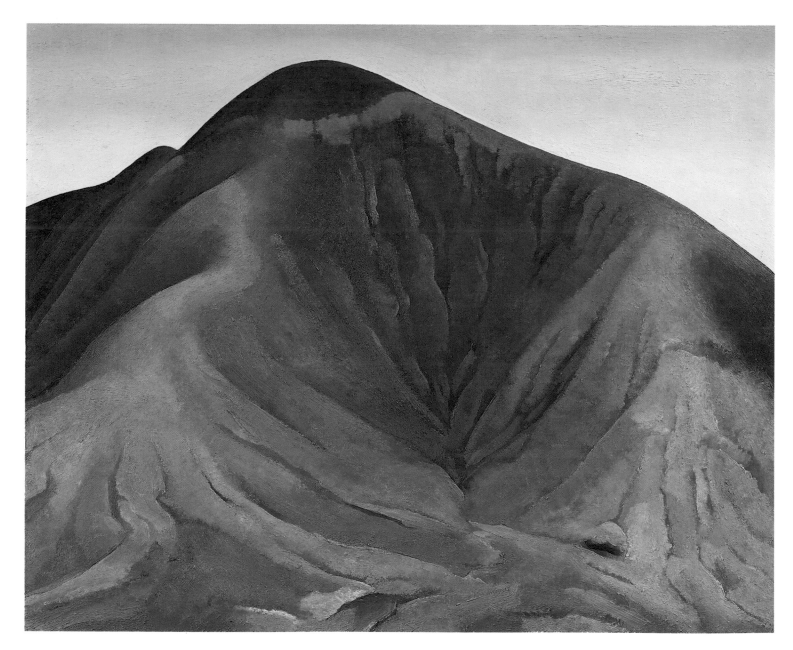

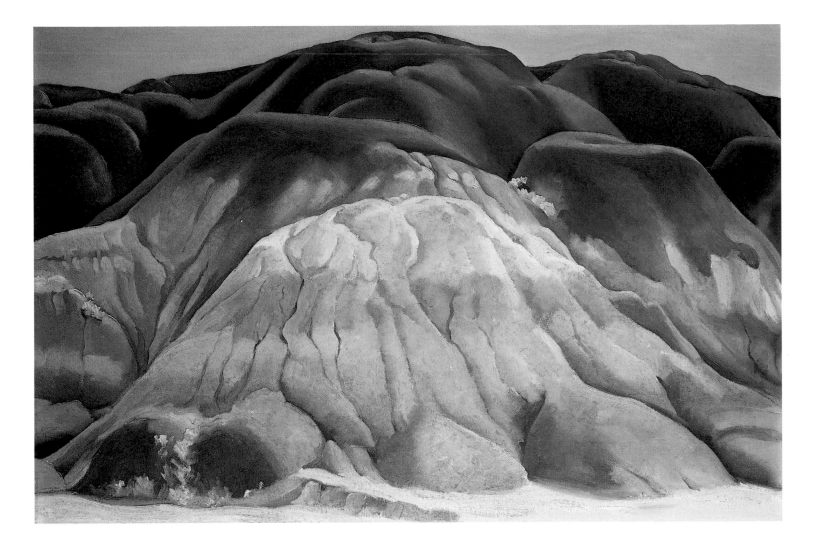

ABOVE:
Black Place 1, 1944
Oil on canvas, 66 x 76.6cm
San Francisco (CA), San Francisco Museum of
Modern Art, Gift of Charlotte Mack

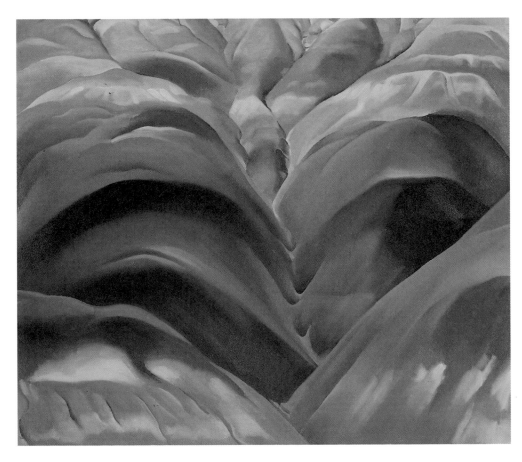

Grey Hills, 1942
Oil on canvas, 50.8 x 76.2cm
Indianapolis (IN), Indianapolis Museum of Art,
Gift of Mr and Mrs James W. Fesler

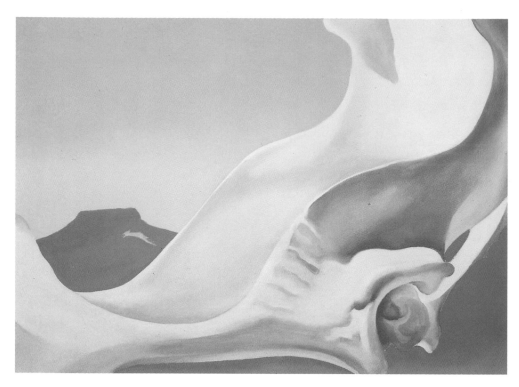

Pelvis with Pedernal, 1943
Oil on canvas, 40.6 x 55.9 cm
Utica (NY), Munson-Williams-Proctor Institute,
Museum of Art

hidden geometry and fundamental structure of nature itself. O'Keeffe expressed her yearning to reveal these "deeper things": "I feel that a real living form is the natural result of the individuals [sic] effort to create the living thing out of the adventure of his spirit into the unknown – where it has experienced something – felt something – it has not understood – and from that experience comes the desire to make the unknown – known – By unknown – I mean the thing that means so much to the person that he wants to put it down – clarify something he feels but does not clearly understand [...] – I some way feel that everyone is born with it clear but that with most of humanity it becomes blasted – (one way or another)." It is as if O'Keeffe, by lending flowers, mountains, cloud formations and water the "design" underlying all things, draws closer to the secret which might be described as the unity of Creation, the mutual harmony of all beings.

ILLUSTRATION PAGE 71:
Pelvis III, 1944
Oil on canvas, 121.9 x 101.6 cm
Collection of Calvin Klein

"When I started painting the pelvis bones I was most interested in the holes in the bones – what I saw through them – particularly the blue from holding them up in the sun against the sky as one is apt to do when one seems to have more sky than earth in one's world."
GEORGIA O'KEEFFE

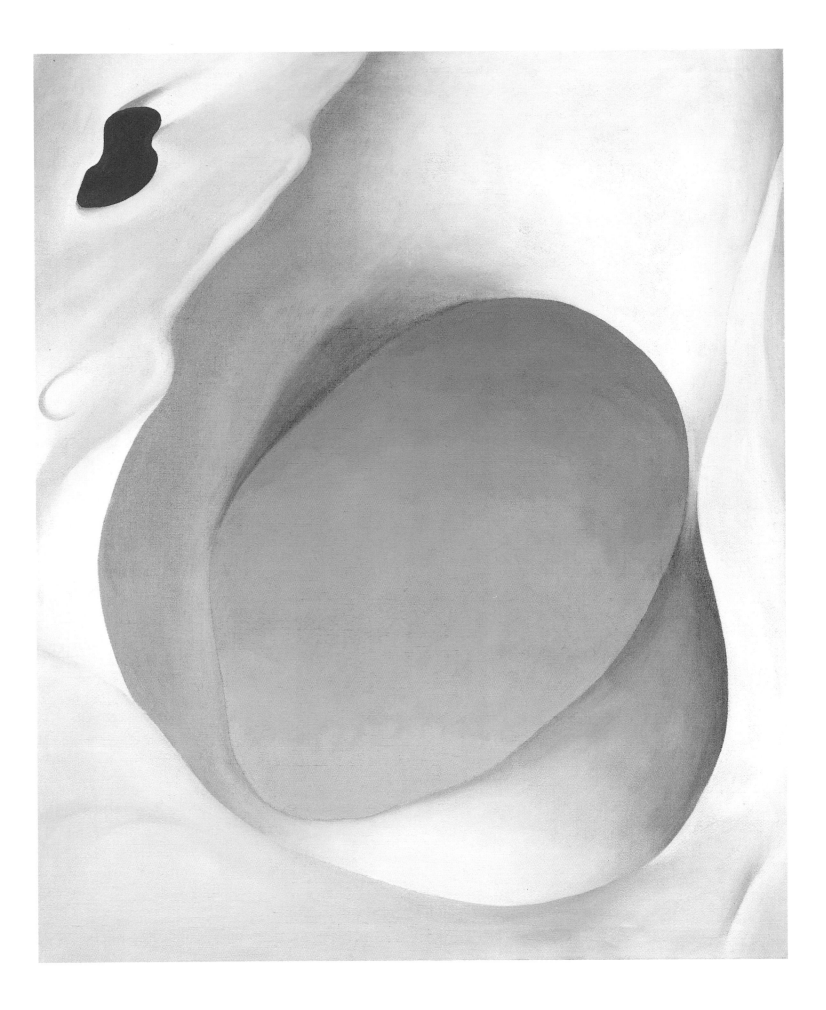

Abiquiu: the patio door

In the spring of 1946, the Museum of Modern Art in New York devoted a retrospective to Georgia O'Keeffe. It was the first time the museum had honoured the work of a woman artist in this way. In July, Stieglitz – now aged 82 – suffered a major heart attack. O'Keeffe, who was spending the summer in New Mexico as she did every year, immediately returned to New York, reaching Stieglitz a few days before his death. In the course of her long relationship with Stieglitz, O'Keeffe got to know many different facets of his personality. "I realized then as I do today," she later wrote, "that living with him for thirty years – I was able to know more than anyone else – both the worst and the best about him. […] I believe it was the work that kept me with him – though I loved him as a human being."

O'Keeffe spent most of the next three years in New York, where she devoted herself to the enormous task of sorting through the collection of art that Stieglitz had left behind and directing it to selected American institutions. She painted few pictures during this period. Any trips to New Mexico were largely spent renovating a semi-derelict adobe house which she had purchased in 1945 in Abiquiu, a village a few miles from Ghost Ranch. She had been particularly drawn to the house by its garden, which allowed her to grow fresh vegetables. With the restoration work finally complete, in 1949 O'Keeffe moved permanently to New Mexico, where she spent the summer months at Ghost Ranch and the winter months in Abiquiu.

The pictures she painted in the 1940s are characterized by single forms dominating the entire pictorial surface, and reflect a stylistic change within her work. They suggest a new attitude towards the landscape that is now her home. This tendency towards increasing simplicity and clarity finds its first expression in her paintings of sun-bleached pelvises of wild desert animals, in which – as in *Pelvis III* of 1944 (p. 71), for example – cavities and gaps offer a view through to an azure blue sky. O'Keeffe loved the powerful blue of the New Mexico sky, which now began to occupy a noticeably larger proportion of her canvases: "When I started painting the pelvis bones I was most interested in the holes in the bones – what I saw through them – particularly the blue from holding them up in the sun against the sky as one is apt to do when one seems to have more sky than earth in one's world... They were most wonderful against the Blue – that Blue that will always be there as it is now after all man's destruction is finished." The pelvises which she started to paint from 1943 onwards are magnified in size. Presented in extreme close-up, each bone is abstracted to such a degree that it functions as no more than a frame for the oval opening in the centre of the picture.

O'Keeffe's intense preoccupation with the renovation of the house in Abi-

Josephine B. Marks:
Georgia O'Keeffe and Alfred Stieglitz, Lake George, c. 1938
Photograph, as published in:
Stieglitz: *A Memoir/Biography* by Sue Davidson Lowe. New York: Farrar Straus & Giroux, and United Kingdom: Quartet Books, 1983.
Courtesy of Sue Davidson Lowe

ILLUSTRATION PAGE 72:
In the Patio I, 1946
Oil on canvas, mounted on cardboard,
76.2 x 61 cm
San Diego (CA), San Diego Museum of Art, Gift of Mr and Mrs Norton S. Walbridge

Laura Gilpin:
Georgia O'Keeffe's Studio, Abiquiu, 1960
Photograph
Fort Worth, © Amon Carter Museum, Laura
Gilpin Collection

The large windows in the studio of the artist's
adobe home in Abiquiu open onto a panoramic
view of the Chama river valley.

quiu, which she undertook herself with the help of a friend and which lasted
three years, is also reflected in her painting. The original adobe architecture
of the inner patio, and in particular the dark patio door, inspired a large
series of paintings, beginning with *In the Patio I* of 1946 (p. 72). From an
open courtyard, the viewer's gaze is guided through an enclosed gap to a
wall visible in the background. The bright, warm sandy brown of the adobe
architecture, together with the gleaming blue of the sky, evoke the atmos-
phere of a hot summer's day and brilliant sunshine. In focussing upon open-
ings and empty spaces, the artist conveys the impression of an unfinished
building. *In the Patio I* may thus document the renovation work begun on
the house that same year and not yet complete.

O'Keeffe designed the interiors of her new home in Abiquiu more con-
sciously than at Ghost Ranch. Each room, furnished simply and sparsely in
line with her needs, reflected her aesthetic tastes. In the most important
room in the house, her studio, large windows afforded sweeping panoramic
views of the Chama river valley (p. 74). One of the few luxuries she allowed
herself to indulge in was an extensive collection of classical music. Along-
side her own pictures, the economical décor included a limited number of
works by other artists, including Alexander Calder, Arthur Dove and Uta-
gawa Hiroshige.

The plainness and clarity of adobe architecture, made of sun-dried clay
bricks, mirrored the functional aesthetic and simplicity which O'Keeffe
prized so highly. She took it up in her painting, both as a symbol of Native
American culture and as a characteristic feature of the New Mexico land-
scape. She was so fascinated by the dark doorway in the wall of her internal
patio that it remained one of her main motifs right up to 1960. In works such
as *Patio with Cloud* of 1956 (p. 77), naturalistic compositional elements such
as wall, floor, tiles and sky are rendered as a sequence of large, simple
colour planes. The fact that O'Keeffe's vision indeed corresponded to the ac-
tual scene before her is demonstrated in the photograph *Patio, O'Keeffe's*

ILLUSTRATION PAGE 75:
Poppies, 1950
Oil on canvas, 91.4 x 76.2 cm
Milwaukee (WI), Milwaukee Art Museum, Gift
of Mr and Mrs Harry Lynde Bradley

In 1946 a retrospective of Georgia O'Keeffe's
work was held at the Museum of Modern Art in
New York. Alfred Barr, founding director of the
museum, had previously already alluded to the
tradition in which her art stood: "This tradition is
more intuitive and emotional than intellectual; in
its forms more organic or biomorphic than geo-
metric; more curvilinear than rectilinear; more
decorative than structural and more romantic
than classical in its emphasis upon the mystical,
the spontaneous and the irrational."

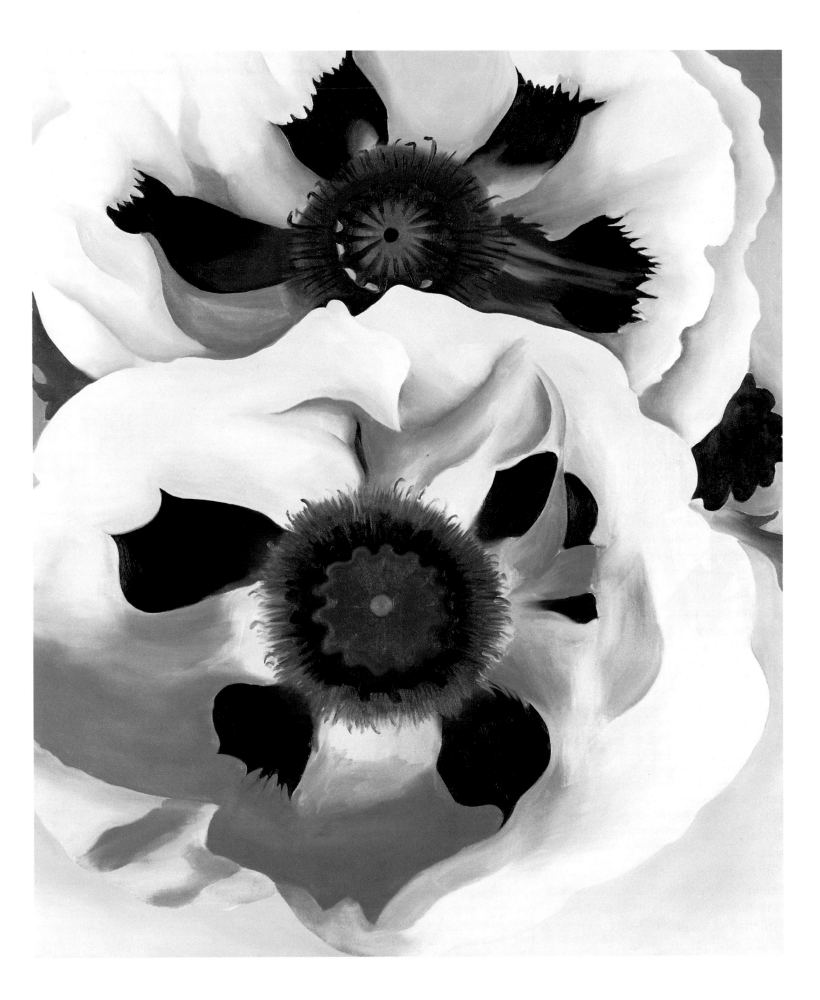

Malcolm Varon:
Patio, O'Keeffe's Home in Abiquiu, New Mexico. Covered Well in the Foreground, 1977
Photograph
N.Y.C., Photo by: Malcolm Varon
© 1994

Malcolm Varon's camera captures the open-air patio within O'Keeffe's Abiquiu house, and in particular the patio door which the artist painted regularly over several decades.

Home in Abiquiu, New Mexico by Malcolm Varon (p. 76). Playing with different perspectives and changing seasonal conditions, O'Keeffe succeeded in capturing her subject in a timeless form. With her geometric, minimalist forms and reduced palette, she appears to anticipate elements of colour-field painting as represented by fellow Americans Kenneth Noland and Ellsworth Kelly. Colour-field painting would become the dominant trend in the New York art scene in the late fifties.

The journalist Blanche Matthias remembered experiencing O'Keeffe's unique way of seeing in the following incident: one day when the two women were out walking together, O'Keeffe asked Matthias to describe the scenery ahead. "I see green trees against the blue sky," Matthias replied. "What do *you* see?" "I see blue sky against the green trees," was Georgia's response.

In 1958 O'Keeffe painted *Ladder to the Moon* (p. 81). Against the backdrop of Pedernal, the mountain which appears so often in her paintings, a ladder leads upwards into the night sky. The fantastic constellation of its subjects, which appear as if enchanted by the spell of the moonlight, lend the picture a surreal magic. A striking analogy to O'Keeffe's *Ladder to the Moon* is found in Joan Miró's painting, *Dog Barking at the Moon*, of 1926 (p. 80). Both artists tend towards a transcendent way of seeing which surmounts the limits of experience.

A photograph showing O'Keeffe in her immediate surroundings on the roof of Ghost Ranch (p. 80) again suggests that the artist may have found the inspiration for *Ladder to the Moon* in reality sooner than in a dream world. The ladder appearing in the painting is seen here leaning against the outer wall of the patio, from where it rises up into the sky against the silhouette of Pedernal in the background. In the lives of the New Mexico Indians, the ladder exercises an important function: it represents the link between the earth and the roofs of the low pueblos, from where they communicate directly with the cosmic forces which lie at the heart of their natural religion, and from where they watch the sunrise and sunset. Bearing in mind the Indians' close relationship with Mother Earth, the ladder may be seen to carry a special symbolic value. By extracting the ladder out of its Native American con-

ILLUSTRATION PAGE 77:
Patio with Cloud, 1956
Oil on canvas, 91 x 76 cm
Milwaukee (WI), Milwaukee Art Museum, Gift of Mrs Edward R. Wehr

ILLUSTRATION PAGE 78:
Patio with Black Door, 1955
Oil on canvas, 101.6 x 76.2 cm
Boston (MA), Gift of the William H. Lane Foundation, Courtesy of Museum of Fine Arts

Georgia O'Keeffe here tends clearly towards the "flatness" so typical of American painting of the post-war period. According to the critic Clement Greenberg, flatness was the most important measure against which art could be judged. Greenberg argued that flatness fulfilled the precondition of painting, namely its two-dimensionality. In the equal tonal value given to all elements of the composition, O'Keeffe's picture assumes characteristics of colour-field painting.

ILLUSTRATION PAGE 79:
Malcolm Varon:
O'Keeffe's home, interior yard, Abiquiu, New Mexico, 1976
Photograph
N.Y.C., Photo by: Malcolm Varon
© 1994

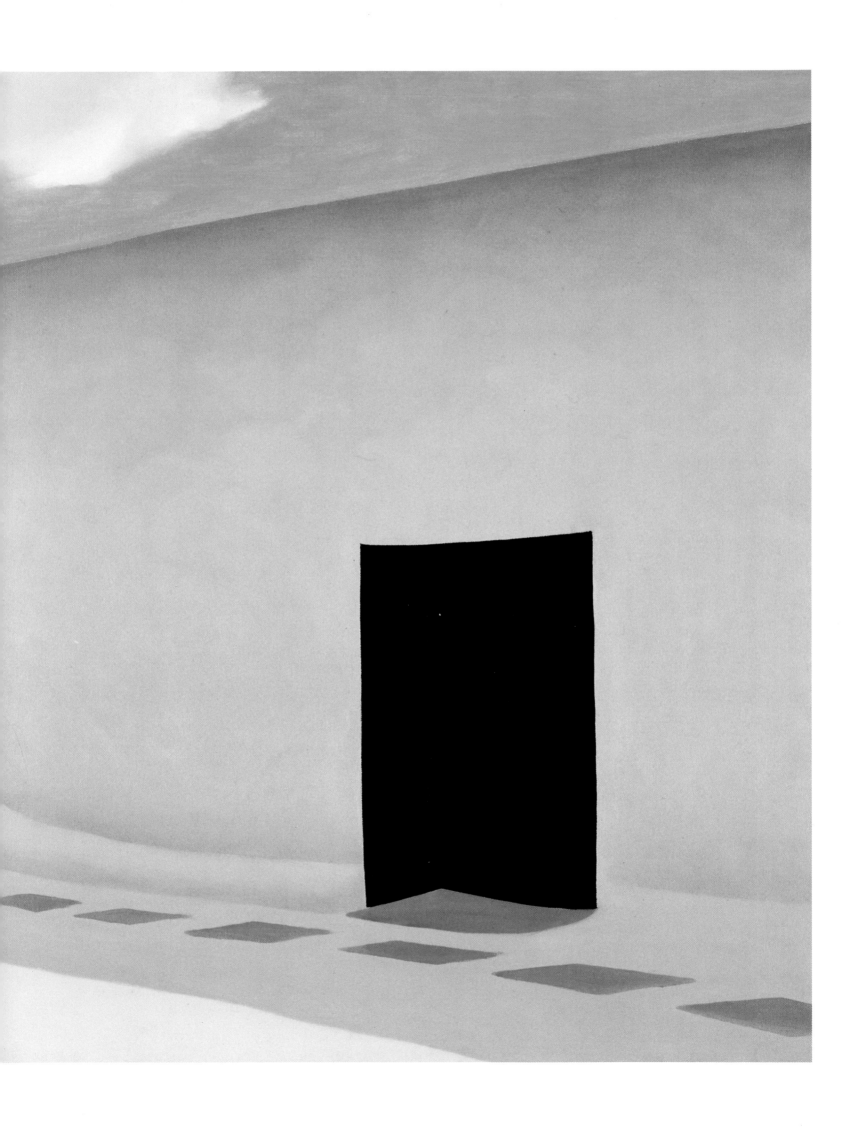

John Loengard:
***Georgia O'Keeffe on the Roof of Ghost
Ranch***, 1966
Photograph
New York, LIFE MAGAZINE
© 1966 Time Warner

Joan Miró:
Dog Barking at the Moon, 1926
Chien aboyant à la lune
Oil on canvas, 73 x 92 cm
Philadelphia (PA), Philadelphia Museum of Art:
A.E. Gallatin Collection

ILLUSTRATION PAGE 81:
Ladder to the Moon, 1958
Oil on canvas, 101.6 x 76.2 cm
New York, Collection Emily Fisher Landau

text and raising it above the ground, O'Keeffe succeeds in fixing on the canvas a common symbol which not only stands for the link between nature and the cosmos but simultaneously touches the universal consciousness of the first inhabitants of New Mexico.

In 1950 O'Keeffe closed down An American Place, Stieglitz' former gallery, and arranged for her work to be represented by the Downtown Gallery. With this release from administrative worries came greater peace and independence. At the start of the fifties, her travels took her beyond the borders of America for the first time. In 1951, accompanied by the writer Spud Johnson, she visited Mexico, where in Mexico City she met the artists Diego Rivera and Frida Kahlo. With Miguel Covarrubias, who had caricatured her as "Our Lady of the Lily" back in 1929 (p. 32), she explored the Mayan sites in Yucatán and Oaxaca, the latter becoming her favourite part of Mexico.

O'Keeffe, who had developed her painting style independently of modern European trends and who had never been to Europe, set eyes on Spain and France for the first time in 1953. In the Prado in Madrid she responded with equal enthusiasm to the pictures by Goya and the works by Oriental artists. For O'Keeffe, who felt herself most closely linked with the culture of Spanish-speaking peoples, Mexico, Spain and Peru – which she visited in 1956 – became the countries to which she would return regularly over the following years.

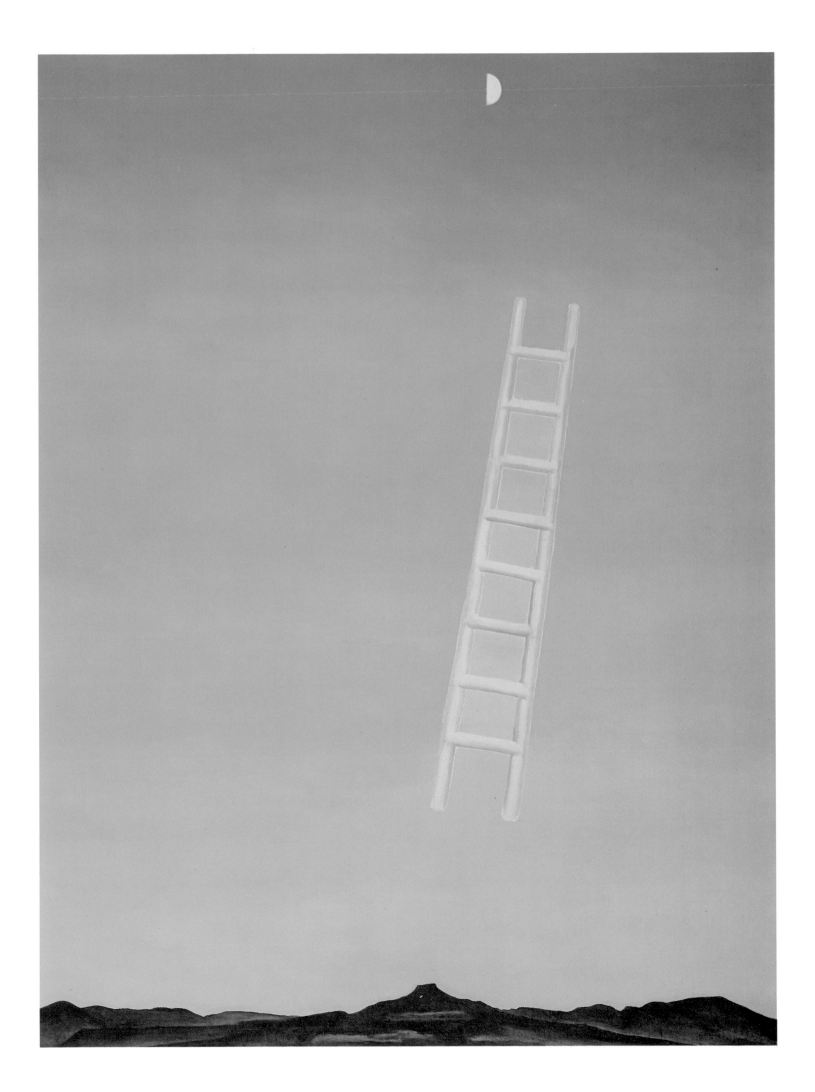

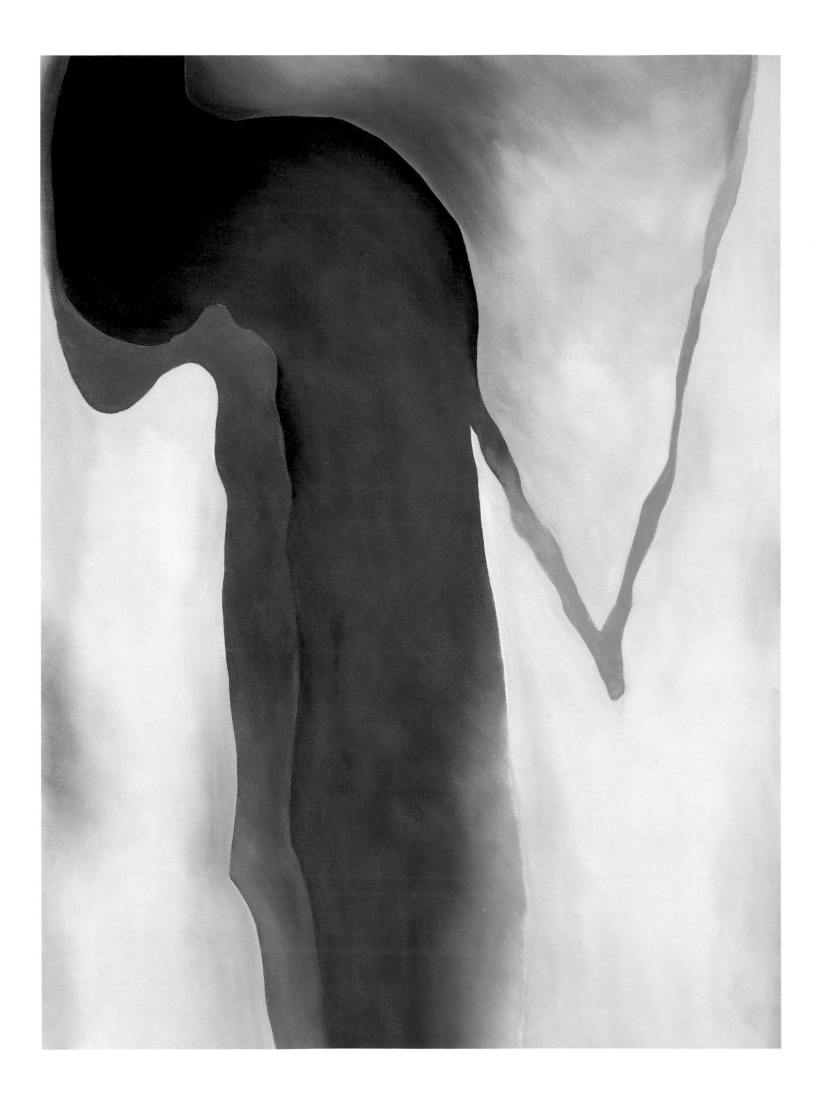

The vastness of space

The trips which O'Keeffe had been taking abroad since 1951 culminated in 1959 with a three-month world tour. The 71-year-old artist visited India, East and Southeast Asia, Pakistan, the Middle East and Italy. Japan, Taiwan, Hong Kong, Cambodia, the Philippines and the islands of the Pacific followed a year later. The view from the aircraft during her long-haul flights between continents provided O'Keeffe with a new subject for her art: rivers carving their course through barren desert regions. The rapid pencil sketches and monochrome charcoal drawings which opened this new series were subsequently followed by oils employing various combinations of colour, such as *It Was Red and Pink*, 1959 (p. 85), *It Was Blue and Green*, 1960 (p. 84) and *Blue, Black and Grey*, 1960 (p. 82). In this series, as in previous works, O'Keeffe again lends expression to her fascination with the alienation of reality.

In their adoption of a disconcerting bird's-eye perspective, these new paintings defy contemplation from the customary horizontal axis. Robbed of conventional centralized perspective, these aerial views portray a depth which extends downwards rather than into the distance. During an exhibition of her pictures in the Downtown Gallery in New York, O'Keeffe was gratified to note that other people saw things in the same way as she did: "Edith Halpert was still my dealer at that time and she wondered what the paintings were about. She thought maybe trees. I thought that as good as anything for her to think – as for me, they were just shapes. But one day I saw a man looking around at my Halpert showing. I heard him remark, 'They must be of rivers seen from the air.' I was pleased that someone had seen what I saw and remembered it my way."

The banks of passing cloud seen from a plane also provided the material for a further series of paintings in the first half of sixties. "One day when I was flying back to New Mexico," O'Keeffe recalled, "the sky below was a most beautiful solid white. It looked so secure that I thought I could walk right out on it to the horizon if the door opened."

O'Keeffe completed the fourth and final work in this *Sky Above Clouds* series in 1965 (pp. 86/87), at the age of 77. Measuring almost 2.5 metres high by over 7 metres wide, it is the largest work in her entire œuvre. It was necessary to convert the double garage at Ghost Ranch into a second studio in order to house the enormous canvas, and here the energetic, strong-willed artist worked every day from 6 o'clock in the morning to 9 o'clock at night in order – because the garage was unheated – to finish the picture before the onset of winter. She grappled indefatigably with the technical problems posed by the size of the canvas, all the time exposed to the constant danger of wild snakes.

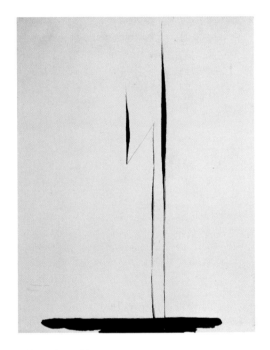

Blue Lines X, 1916
Watercolour, 63.5 x 48.3 cm
New York, The Metropolitan Museum of Art,
Alfred Stieglitz Collection, 1969

ILLUSTRATION PAGE 82:
Blue, Black and Grey, 1960
Oil on canvas, 101.6 x 76.2 cm
Mr and Mrs Gilbert H. Kinney

This painting, according to Georgia O'Keeffe, shows a river seen from a bird's-eye perspective. But it is also, of course, an abstract composition, a further example of the self-motion of painting towards pure, non-representational two-dimensionality. In its superimposition of abstraction and figuration, it is also a typical example of the romantic tradition in art.

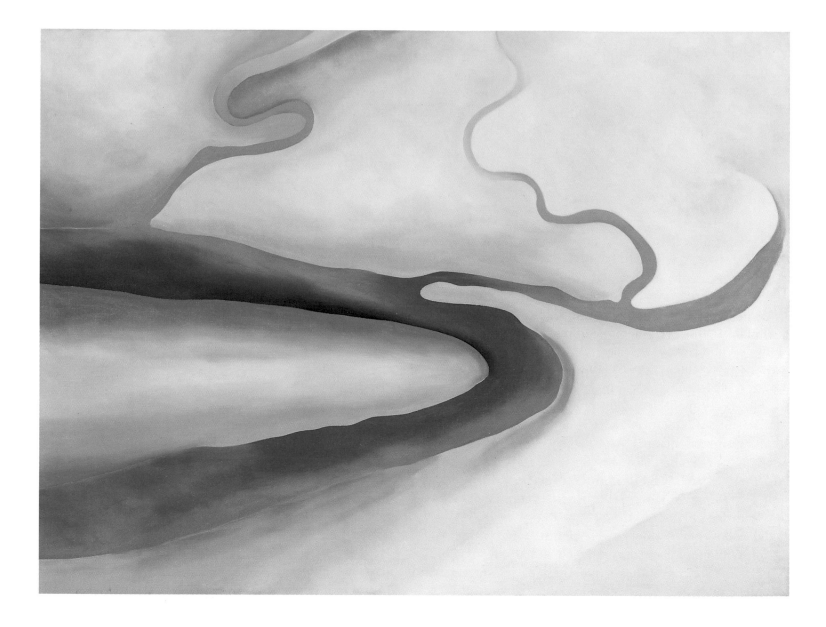

It Was Blue and Green, 1960
Oil on canvas, mounted on cardboard,
76.4 x 101.9cm
New York, Collection of Whitney Museum of
American Art, Lawrence H. Bloedel. Bequest
77.1.37

The small oval clouds in *Sky Above Clouds IV*, which extend towards the distant horizon like an endless white carpet of vapour, may be understood as a symbol of the intangible dimension of atmospheric quality. These cloud compositions take up the theme of spatial relationships running through the pictures of the earlier *Patio* series, but suggest an even greater striving towards boundlessness and universality.

Following two retrospectives in the Worcester Art Museum in Massachusetts and the Amon Carter Museum in Fort Worth, Texas, which both featured O'Keeffe's work from the sixties, the major retrospective at the Whitney Museum of American Art in New York in 1970 marked a turning-point in terms of the public reception of her art. The tremendous success of the exhibition and the nationwide recognition it brought her work cemented O'Keeffe's position as an "icon" in American art. Critics viewed her as an important forerunner of contemporary American art – both of abstract expressionism and colour-field painting. Georgia O'Keeffe felt a particular affinity for the work of Ellsworth Kelly, whose paintings and sculptures, however extreme their minimization, always had their origins in natural forms, such as the sweeping curve of a mountainside. "Sometimes I've thought one of his things was mine," she said in autumn 1973."I've actually looked at one of Kelly's pictures and thought for a moment that I'd done it."

Like the writer Anaïs Nin, Georgia O'Keeffe now became the idol of a new

generation of feminists and the personification of the modern, independent woman. Public recognition of her achievements was documented in a succession of awards and distinctions. In 1977 she was decorated with the Medal of Freedom, the highest civil order, by President Gerald Ford. O'Keeffe was also the subject of the documentary "Portrait of an Artist", filmed by Perry Miller Adato and broadcast on television to coincide with her 90th birthday. The film shows the artist living in perfect harmony with her surroundings and makes uniquely clear her oneness with the desert landscape.

In 1971 O'Keeffe's eyesight began to deteriorate. Although the world around her became increasingly blurred, she could still recognize simple patterns and shadows. In 1973 Juan Hamilton, a young potter, entered her life. Both benefitted from the relationship which now developed between them: O'Keeffe, more dependent upon the help of others than ever before, enjoyed the attention and care which Hamilton bestowed upon her. Hamilton motivated her to continue painting, and she started experimenting with clay, a new material for her. Encouraged by Hamilton, in 1975 she captured the colours and forms which she could still see with her peripheral vision in watercolours and – with the help of an assistant – oils. Of the many young artists seeking her advice, Hamilton was the only one with whom she shared her vast experience.

It Was Red and Pink, 1959
Oil on canvas, 76 x 101 cm
Milwaukee (WI), Milwaukee Art Museum, Gift of Mrs Harry Lynde Bradley

The development towards abstraction which can be seen in Georgia O'Keeffe's later œuvre was both logical and consistent with contemporary trends. Together with such artists as Barnett Newman, Mark Rothko, Adolph Gottlieb and Clifford Still, she brought together the two main strands of American art in the 20th century: on the one hand, the spontaneous movement in painting towards pure flatness, and on the other the romantic tradition with its emphatic feeling for the external world of nature and the intuition within the individual.

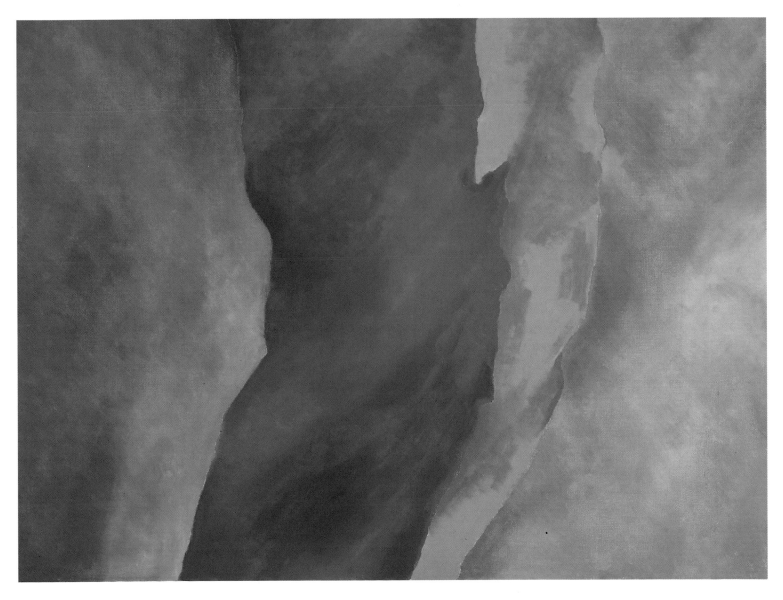

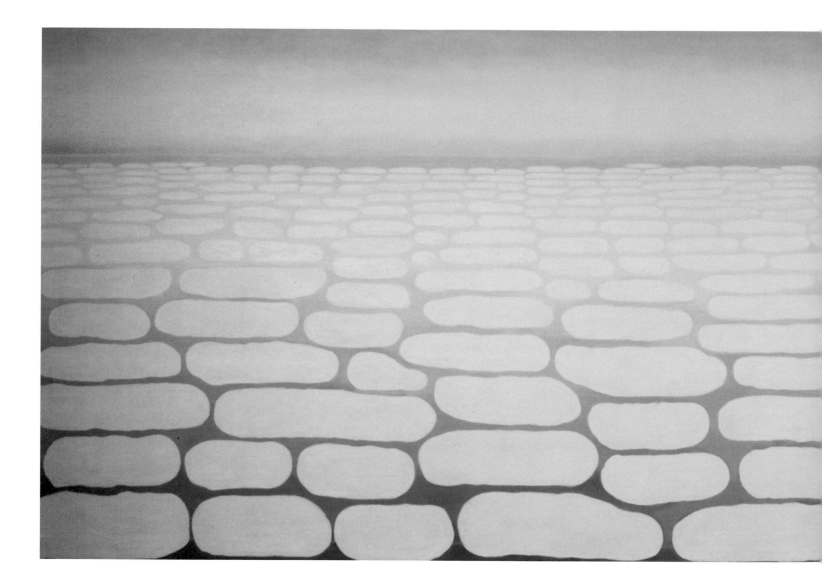

Sky Above Clouds IV, 1965
Oil on canvas, 243.8 x 731.5 cm
Chicago (IL), The Art Institute of Chicago, Restricted gift of the Paul and Gabriella Rosenbaum Foundation, Gift of Georgia O'Keeffe, 1983.821

"The Sublime is now," declared Barnett Newman. "The image we produce is the self-evident one of revelation, real and concrete, that can be understood by anyone who will look at it without the nostalgic glasses of history." The all-embracing quality of nature which O'Keeffe had always sought to express here has its pendant in a painting which, through its very size alone, surrounds the viewer and produces a sublime, exalted effect.

Over the following years Hamilton remained her sole assistant, helping her with the preparation of exhibitions and publications and also accompanying her on numerous trips. She took her last such trip in 1983 at the age of 96, when she returned to the Pacific coast of Costa Rica. In 1984, on health grounds, she left her beloved house in Abiquiu and moved to Santa Fe, where she spent the final two years of her life with Hamilton and his family in what was for her an uncharacteristically large house. Even at the age of 97 she still enjoyed reading excerpts from Kandinsky's *Concerning the Spiritual in Art*. Georgia O'Keeffe died on 6 March 1986 at the age of 98 in Santa Fe. At her own wish, her ashes were scattered over the countryside around Ghost Ranch which she loved so much. In 1987, to celebrate the centennial of her birth, the National Gallery in Washington honoured her work with a major exhibition for which she had been personally involved in the planning before her death.

For decades during her lifetime, analysis of O'Keeffe's work was limited to a rigid fixation upon what were considered to be its essentially female aspects. It is only since her death that more discriminating opinions have begun to be voiced. O'Keeffe, who rarely spoke about her models and

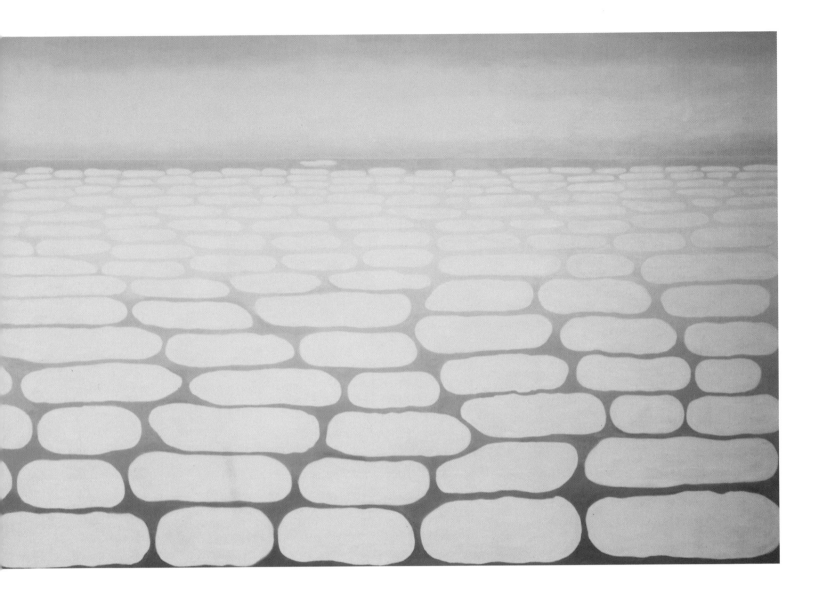

Malcolm Varon:
ChamaValley and Rock Collection, 1976
Photograph
N.Y.C., Photo by: Malcolm Varon
© 1994

Dan Budnik:
Georgia O'Keeffe in the Pottery Workshop,
1975
Gelatin silver print
© 1975 Dan Budnik/Woodfin Camp/Focus

With the deterioration of her eyesight, Georgia
O'Keeffe sought new forms of artistic ex-
pression and began experimenting with clay.

ILLUSTRATION PAGE 89:
Black Rock with Blue III, 1970
Oil on canvas, 50.8 x 43.2 cm
© Juan Hamilton

"Now and then when I get an idea for a picture, I
think, how ordinary. Why paint that old rock?
Why not go for a walk instead? But then I realize
that to someone else it may not seem so ordi-
nary." GEORGIA O'KEEFFE

sources and who distanced herself from intellectualized theories of art, un-
doubtedly contributed to the image of herself as an intuitive artist entirely
untouched by outside influences. The process of demythologizing Georgia
O'Keeffe's art will undoubtedly be carried a major step forward by the cata-
logue raisonnée currently being prepared in cooperation with the Washing-
ton National Gallery and the Georgia O'Keeffe Foundation; scheduled for
publication in 1996, it will offer a factual overview of the almost 2000
works which make up the artist's œuvre.

Painting was Georgia O'Keeffe's life, and it was as an artist that she wanted
to be understood. Her art echoed her belief in the power and imperishability
of nature, a belief which she expressed in countless landscapes and still lifes.
She was always receptive to other contemporary trends in art, and photo-
graphy in particular introduced her to a new way of looking at things. Her
ideal of beauty – harmony, proportionality, simplicity and elegance – finds
parallels in the art and lifestyle of the Far East, in which even the smallest
everyday things are assigned a significance. O'Keeffe loved Chinese paint-
ing, whose uncrowded spaces are an invitation to meditation. Her goal was
not painting for painting's sake. Although her pictures at first sight appear
easily accessible, they only yield up their true meaning after intense contem-
plation. O'Keeffe's special predilection for repeating certain patterns, forms
and images and rephrasing them into ever new variations and combinations
may be seen as a mark of her efforts to render visible the divine harmony
which embraces and connects all beings.

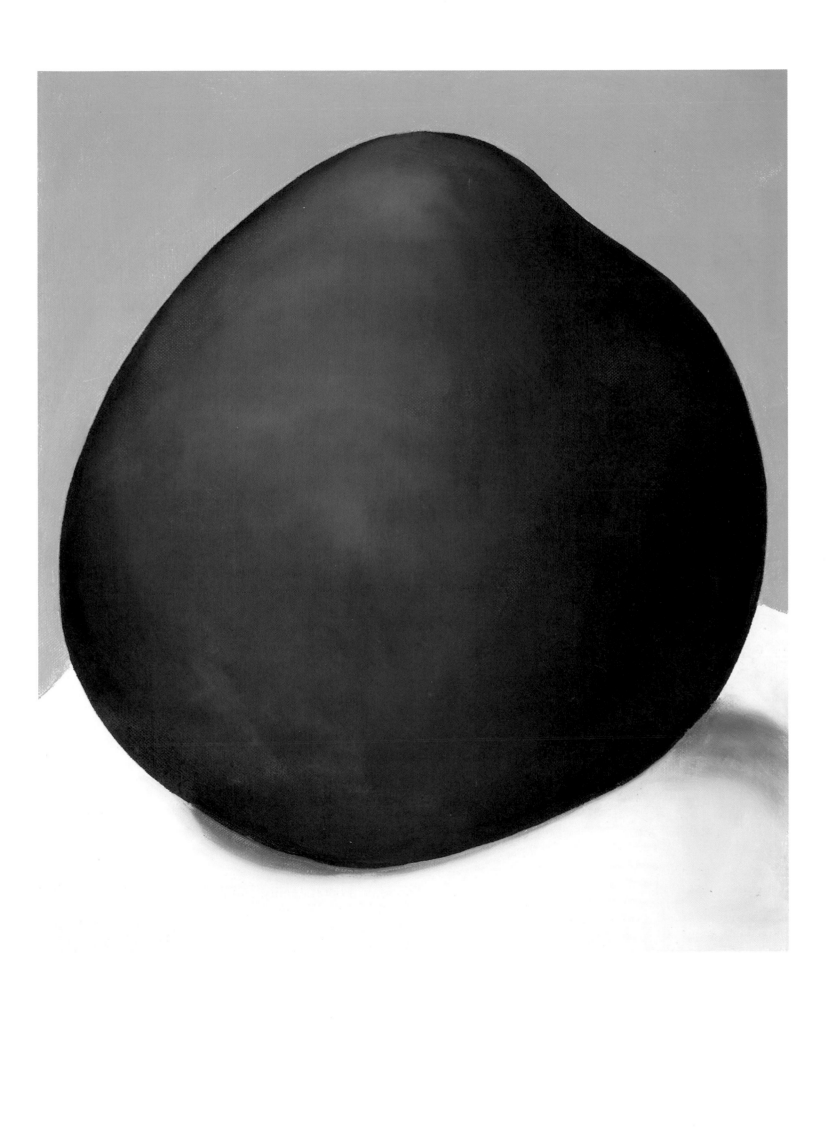

ILLUSTRATION PAGE 91, ABOVE:
Evening Star No. VI, 1917
Watercolour, 22.9 x 30.5 cm
Private collection

"Georgia O'Keeffe [transforms] primary phe-
nomena in nature into almost heraldic patterns.
In such a watercolor as *Evening Star No. III* of
1917, she [...] distills the polarity of the earth
below and a luminous heavenly body above into
a simplified emblem that recalls nature in some
primeval state, where liquid light and color have
not yet congealed into matter and discrete ob-
jects."
ROBERT ROSENBLUM, *Modern Painting and
the Northern Romantic Tradition*, 1975

Malcolm Varon:
Tool and Storage Area, Abiquiu, 1976
Photograph
N.Y.C., Photo by: Malcolm Varon
© 1994

Georgia O'Keeffe's art was inseparably bound up with her personality. The
simple, clear and poetic character of her painting is equally reflected in her
language. It was this oneness with herself that became part of the myth
which surrounded her. As her friend Ansel Adams said of her three years be-
fore her death: "She still has a mystique, I call it. It's automatic. She's just
O'Keeffe. She wears a certain kind of clothes, has a certain manner. She's a
very great artist. Nobody can look at a painting without being deeply af-
fected. So the mystique begins and endures."

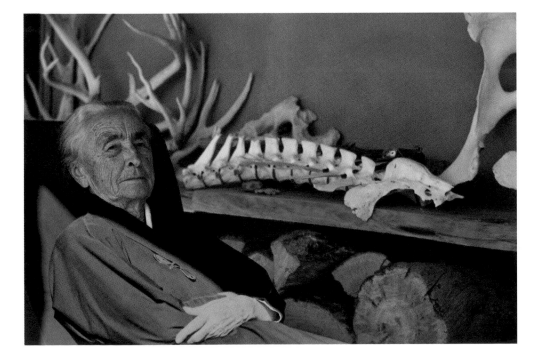

Malcolm Varon:
Georgia O'Keeffe at the Age of Ninety, 1977
Photograph
N.Y.C., Photo by: Malcolm Varon
© 1994

Georgia O'Keeffe – Life and work

1887 Georgia O'Keeffe is born on 15 November near Sun Prairie, Wisconsin, as the second child of Francis Calyxtus O'Keeffe, a farmer, and his wife Ida Totto O'Keeffe.

1903 Georgia follows her family, who left Wisconsin a year earlier, to Williamsburg, Virginia. She completes her education at the Chatham Episcopal Institute in Chatham, Virginia.

1905 She enrols as a student at the Art Institute of Chicago.

1907 After a serious bout of typhoid fever, she continues her studies at the Art Students League in New York.

1908 She pays her first visit to the "291" gallery run by Alfred Stieglitz, where she sees life drawings by Rodin. She wins a scholarship to the League Outdoor School at Lake George for the best still life in her class. In autumn, her family's straightened circumstances oblige her to earn her own living as a commercial artist in Chicago.

1910 She has to give up her job in Chicago when her eyesight is affected by a bout of measles.

1912 She returns to painting with a summer class at the University of Virginia run by Alon Bement, a pupil of Arthur Dow. At Bement's suggestion, she becomes a teaching assistant at the University of Virginia summer school every year until 1916. In order to gain the necessary classroom experience, she works for two years as an art teacher in Amarillo, Texas.

1914 At Bement's recommendation, Georgia O'Keeffe enrols at the Columbia University Teachers College in New York. Here she studies under Arthur Dow for a year, returning for a further term in the spring of 1916. She follows the latest exhibitions at "291" and joins the National Women's Party.

Rufus Holsinger:
Georgia O'Keeffe at the University of Virginia, 1915

1915 At the end of the year she takes up a teaching post at Columbia College, South Carolina.

1916 The charcoal drawings she has produced in South Carolina are exhibited by Alfred Stieglitz at his New York gallery "291" in May. In autumn she becomes head of the art department at the West Texas State Normal College in Canyon, where she remains throughout the year 1917.

1917 Stieglitz organizes her first solo show at "291", comprising charcoal drawings and watercolours, and takes the first of the – over 300 – pictures which will make up his comprehensive photographic portrait of the artist. In the autumn of this year Georgia travels to Colorado with her sister; on the way they pass through New Mexico, and Georgia sets eyes for the first time on the landscape that will fascinate her all her life.

1918 Stieglitz' financial support enables her

to devote herself entirely to painting, and she moves to New York. Over the coming years she spends her summers at the Stieglitz' family property on Lake George and her winters in New York City.

1923 At the start of the year Stieglitz stages the first large show of her work, featuring 100 drawings and paintings, at the Anderson Galleries in New York.

1924 51 paintings by O'Keeffe and 61 photographs by Stieglitz, most of them portraits of the artist, are exhibited concurrently at the Anderson Galleries. Georgia O'Keeffe and Alfred Stieglitz are married on 11 December.

1925 In the "Seven Americans" show at the Anderson Galleries, O'Keeffe's flower paintings are exhibited for the first time alongside works by other members of the circle grouped around Stieglitz.

1926 As she had already done in 1920 and would do again in 1928, Georgia interrupts her Lake George/New York rhythm and goes alone to York Beach, Maine. From now until 1930, her most recent works are shown at the Intimate Gallery opened by Stieglitz in Park Avenue at the end of 1925.

1927 In June, the Brooklyn Museum in New York holds the first small retrospective of her work. In July and December she undergoes two breast operations, from which it takes her a while to recover.

1929 In April, at the invitation of Mabel Dodge Luhan, she travels to New Mexico, where from now on she will regularly spend her summers.

1930 Her latest pictures, featuring motifs from the Southwest, are exhibited annually at An American Place, Stieglitz' new gallery, from now until its closure in 1950.

Georgia O'Keeffe in Greece, 1963

1932 Accompanied by Georgia Engelhardt, she goes on a painting trip to Canada. In November she suffers a nervous breakdown and is forced to give up painting for an extended period.

1933 In February she is diagnosed as suffering from psychoneuroses and is admitted to hospital. She later convalesces in Bermuda.

1934 The Metropolitan Museum of Modern Art acquires its first painting by Georgia O'Keeffe. She spends her first summer at Ghost Ranch, New Mexico, where in 1940 she buys a house and some land.

1939 Accepting a commission from the Dole Pineapple Company, she travels to Hawaii in order to paint pictures for promotional purposes. The New York World's Fair Tomorrow Committee votes her one of the twelve outstanding women of the past 50 years.

1943 The Art Institute of Chicago holds the first major retrospective of her work.

1945 In Abiquiu, a village near Ghost Ranch dating back several centuries, she purchases a dilapidated adobe house which she renovates completely over the next three years.

1946 In May the Museum of Modern Art in New York stages a retrospective of her work. It is the first solo show the museum has ever dedicated to a woman. Alfred Stieglitz dies on 13 July at the age of 82.

1949 After settling Stieglitz' estate and delegating his art collection to various American museums and institutions, O'Keeffe moves permanently to New Mexico.

1952 With An American Place now closed, the Downtown Gallery in New York takes over the representation of her work.

1953 At the age of 66, she makes her first trip to Europe, visiting France and Spain, to which latter she returns in 1954.

1956 She spends three months in Peru and the Andes, where she visits the historic Inca sites.

1959 She embarks upon a three-month world tour, seven weeks of which are spent in India.

1960 The Worcester Art Museum, Massachusetts – like the Amon Carter Museum in Fort Worth, Texas, in 1966 – holds a retrospective of her work. O'Keeffe travels to Japan and the islands of the southeast Pacific.

1961 She goes rafting down the Colorado River with a group of friends. She repeats the trip in 1969 and 1970.

1962 She is elected a member of the American Academy of Arts and Letters, an association of outstanding American artists, adding to the many distinctions which she has received since 1938, and which will increase during the sixties and seventies.

1963 Her travels abroad take her to Greece, Egypt and the Middle East.

1970 Her largest retrospective to date is held at the Whitney Museum of American Art in New York, introducing her work to a younger generation.

1971 Her eyesight deteriorates significantly.

1973 At the encouragement of her young assistant Juan Hamilton, she begins experimenting with clay. Between now and 1983 she makes trips to Morocco, Antigua, Guatemala, Costa Rica and Hawaii, accompanied by Hamilton.

1976 The book *Georgia O'Keeffe*, designed and with an accompanying text by the artist, is published by the Viking Press.

1977 Perry Miller Adato's film about O'Keeffe, entitled "Portrait of an Artist", is broadcast on American television.

1978 The Metropolitan Museum devotes an exhibition to Alfred Stieglitz' photographic portrait of O'Keeffe. She writes the introduction for the catalogue.

1983 Her last trip overseas takes her to the Pacific coast of Costa Rica.

1986 Georgia O'Keeffe dies on 6 March in Santa Fe, at the age of 98.

1987 The National Gallery of Art in Washington celebrates the centennial of her birth with a large exhibition, which was already being planned while she was still alive.

1989 The Georgia O'Keeffe Foundation is inaugurated for the purposes of managing the artist's estate and looking after the works in her bequest. A catalogue raisonnée is currently in preparation and is provisionally scheduled for publication in 1996.

<u>Malcolm Varon:</u> View of the studio from the back of the house, Abiquiu

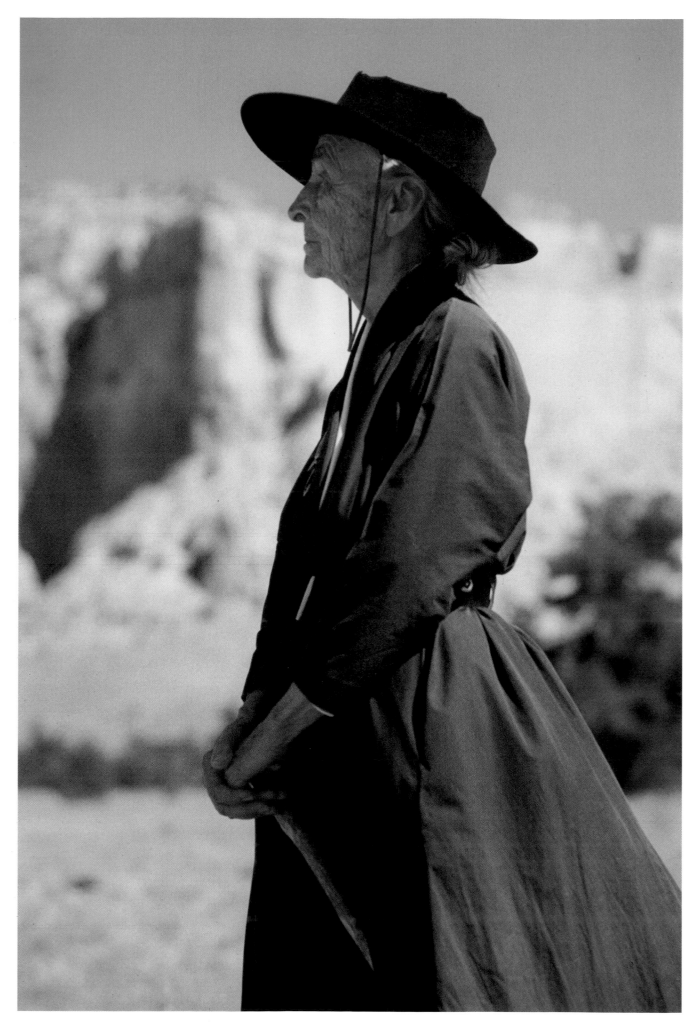

94 <u>Malcolm Varon:</u> Georgia O'Keeffe at the age of ninety at Ghost Ranch, New Mexico, 1977

The publishers wish to thank the museums, pictorial archi-
ves, photographers and collectors for kindly supplying the
following illustrations:

Ben Blackwell: 69
Museum of Fine Arts, Boston, All rights reserved: 78
The Art Institute of Chicago, All rights reserved,
Photograph © 1993: 14, 16, 47, 59, 86
Geoffrey Clements, New York: 8, 33
Efraim Lev-er, Milwaukee, 1993: 75
Copyright © Steve Sloman, 1989, New York: 54, 84
Joseph Szaszfai, New Haven: 19
Collection of the Center for Creative Photography, Tucson:
88
Photograph by: Malcolm Varon © 1987, N.Y.C.: 26, 36
Photograph by: Malcolm Varon © 1994, N.Y.C.: 6, 8, 10,
11, 12, 13, 14, 15, 20, 22, 23, 25, 29, 30, 34, 37, 39, 41, 49,
50, 53, 57, 61, 62, 65, 67, 68, 69, 71, 81, 82, 89, 91, 93, 94
Holsinger Studio Collection, Special Collections Depart-
ment, Manuscripts Division, University of Virginia Library
Charlottesville: 92
Copyright © The Georgia O'Keeffe Foundation, Abiquiu:
93 above

In this series: